IMAGES
of America
PHOENIX'S GREATER
CORONADO NEIGHBORHOOD

IMAGES
of America

PHOENIX'S GREATER
CORONADO NEIGHBORHOOD

Donna J. Reiner and Jennifer Kitson

ARCADIA
PUBLISHING

Published by Arcadia Publishing
Charleston, South Carolina

Printed in the United States of America

Library of Congress Control Number: 2011940761

For all general information, please contact Arcadia Publishing:
Telephone 843-853-2070
Fax 843-853-0044
E-mail sales@arcadiapublishing.com
For customer service and orders:
Toll-Free 1-888-313-2665

Visit us on the Internet at www.arcadiapublishing.com

"One great block after another!"

CONTENTS

ACKNOWLEDGMENTS

We sincerely thank everyone who graciously looked for pictures, both those who found them and those who were only able to share verbal memories. The stories accompanying the pictures were influential in providing the intimate details of the neighborhood that are not always captured in traditional history books. We owe much gratitude to the various local archives and friendly archivists who provided a wealth of information. In particular, we'd like to extend many thanks to those archives who provided extensive assistance including the Arizona State Archives, the Arizona Historical Society, the Phoenix Public Library, the Salt River Project Research Archives, the Phoenix Elementary School District, and the Phoenix and Arizona Historic Preservation Offices. Special thanks go to several people who this publication critically depended on. JoAnn Trapp and Nona DiDomenico have lovingly cared for this neighborhood over many years. Without their combined efforts to save records from the Augustana Lutheran Church and Neighborhood Housing Services, we would not have been able to adequately show how important they were to this neighborhood. Much of Coronado's recent history has been preserved thanks to the archival efforts of Maureen Rooney, who also graciously read the manuscript while moving. Holly Heizenrader's technical skills helped ensure the images in the book were accurately reproduced. Finally, we'd like to thank all the contributing photographers, both past and present, whose image-making ensures a shared history.

All images from the *Arizona Republic* are used with permission. Permission does not imply endorsement.

INTRODUCTION

Increasingly, urban places are understood to be made through a complex and intricate assemblage of matter and "matterings:" zoning maps; pipes, cables, wires, and digital signals; bricks and mortar; termites and feral cats; dreams, secrets, and histories; favorite coffee shops; meteorological events; and much, much more. Whether seemingly too ephemeral to last or too enduring to change, all materialities have agency, the capacity to affect. With such a multitude of existing attributes in play and increasingly new digital networks promising to relegate geography to a mere afterthought, it seems impossible that familiar objects, like a "neighborhood" or a "community," still manage to take shape. Yet, as this book attests, they do.

Understanding the way a neighborhood bubbles to the surface from so many diverse and disparate parts necessitates new strategies. Rigid boundaries and fixed meanings cannot possibly grasp the dynamism of place; linear inventories omit the rhythmic tempos of time. Instead, it is important to take seriously the everyday materiality and practices. The contours of a neighborhood, an identifiable character, tone, and shape, take form through the ordinary, routine, day-to-day tasks of living.

With these ideas in mind, the images and text that follow attend to the array of residents, homes, institutions, infrastructure, and practices that have contributed to the emergence of the greater Coronado neighborhood. Instead of a chronological time line, we tell the story of Coronado through collections of attributes to emphasize the multitude of actors at different times and for varying durations. By drawing attention to the features and materials of the homes and what residents did and do, we explore how Coronado came to be and continues to cohere.

This exploration into the evolution of Coronado also demonstrates how and why the neighborhood still matters in an era and location of rapid change. Coronado shares three increasingly ubiquitous qualities with places across the country that, upon first glance, are seemingly difficult to organize into a neighborhood. By elevating the multitude of actors, from types of cement to flavors of ice cream, in understanding how places are made, we make the case that being ordinary, urban, and diverse are critical assets in the evolution of the Coronado neighborhood.

First built as a working class streetcar suburb, "the Coronado" embodies a particularly ordinary, "everyman" domestic story of Phoenix. The three residential historic districts located in the greater Coronado neighborhood were designated precisely because of this representativeness, not the legacies of the rich, famous, or social elite. As such, inquiry into Coronado gives insight into the everyday lives of average Phoenicians for almost 100 years. In fact, the dialogue between the neighborhood's first and current residents continues daily because historic preservation is carried out through inhabitation. The homes of the past are preserved by going about the everyday tasks of living, making decisions about decorating rooms, repairing windows, and refurbishing floors with conversations being brought up about what furnishings were common, what materials would have been used, and what color might have been chosen. Peeling paint, found marbles, and grooves in the floor become evidence of past practices, the fodder for creative narratives and the basis for future decisions.

For example, the limited financial resources of early Coronado residents necessitated structural features of the residential properties that have since been reimagined by today's inhabitants. Small

closets are now cited as opportunities to "downsize," reduce meaningless over-consumption, and pursue more ecologically sustainable lifestyles. During the Great Depression, families moved into their garages, renovating them into "granny flats," so that they could turn the main house into a rental. Today, these "guest houses" are again income-generating features of homes in Coronado that enable an array of family sizes to find affordable housing. In this way, routine domestic practices, past and present, entwine to make place here.

Second, this modest streetcar suburb has survived, and even thrived, despite (or because of) urbanization. Between 1945 and 1960, white flight, red-lining, urban disinvestment, population growth, and the federal subsidization of newly constructed homes on the periphery created a new geography. Located at what used to be the northernmost edge of Phoenix, Coronado transitioned to a central or inner city neighborhood by the 1970s.

In 1975, when the nonprofit Neighborhood Housing Services of Phoenix (NHS) chose Coronado for its pilot urban revitalization program, the neighborhood was in rapid decline. Deteriorating housing stock, abandonment, blight, and a declining population of homeowners rendered the community highly unstable. By 1978, NHS had achieved two major accomplishments through strategic partnerships between residents, financial lenders, and the City of Phoenix: the creation of a high-risk revolving home rehab loan fund and the city's first infill development. These oft forgotten efforts of community organizers, residents, city workers, and lenders have engendered neighborhood-building practices in Coronado that survive to this day.

Finally, Coronado boasts two distinctive neighborhood attributes that urbanists dream about—diversity and creativity—while managing to defy many of the exclusionary features that come with strong identity. With such a sizable land area and home to three different historic districts, it seems unlikely that Coronado could maintain a sense of connectedness and neighborhood identity. A single intersection in Coronado, Twelfth and Oak Streets, reveals the legacy of diversity and creativity here. In 1984, this intersection was home to the Arizona Showmen's Association (a social organization composed of Arizona's carnival community), the Professional Musician's Union, and a neighborhood market (the latter two still reside at this intersection). Twenty-five years later, artistic practices abound: the May 2011 issue of *Phoenix Magazine* named the Coronado neighborhood as one of the top 10 best places to live in the Valley, fondly referring to it as "Funkytown," an eclectic community especially for "burning man habitués and people forever looking for 'the next Willo'" (a lovely, upscale Phoenix historic district).

Enter the neighborhood from any direction and this description—diverse or eclectic, artsy or creative—seems fitting. The perimeter of the neighborhood hosts a variety of businesses and services, including the Phoenix Country Club, Band-Aids (a strip club), Mercer Mortuary, Banner Good Samaritan Hospital, Foundation for Senior Living, Home Base Youth Services, New India Bazaar, Gourmet House of Hong Kong, a religious supplies store, a soda fountain, hair salons, dozens of local eateries (from the expensive Coronado Café and Barrio Café to the affordable—*carnicerias*, taquerias, *dulcerieas*, and Jack-in-the-Box), and more. Within the neighborhood there are a number of schools (elementary, high school, and Montessori), churches (at least five), Sikh temples (two), and parks (three).

Though it is spoken often in central Phoenix, the name "Coronado" no longer enlivens an imagery of 16th-century Spanish conquest. Instead, with each utterance, a new assemblage is called into being: period revival architecture, murals, home tours, art and architecture, community gardening, and an obsession with glass doorknobs, telephone nooks, and milk doors. This whirl of matter and matterings is the greater Coronado neighborhood. In the following pages, historical narrative, tidbit, and fact are intertwined with memories, stories, and of course, the images themselves. We hope these new actors will add to the lively complexity of Coronado as it continues to unfold from the changing habits of residents, the future changes to infrastructure and building materials, and the formation of new social institutions. To borrow from an Estonian proverb printed in an old Neighborhood Housing Services pamphlet, "The town is new everyday."

One

THE EARLY DAYS OF PHOENIX

Phoenix, Arizona developed from an early settlement that sprang up along the Salt River following the construction of Camp McDowell in 1865. Thus, the city has no Spanish colonial history despite being in the southwest. Agriculture was the primary industry of those early settlers providing many of the necessary goods for the nearby military installation.

As more people gradually moved to the area, the need for a formal townsite became clear. Following a meeting in October 1870, a 320-acre site was eventually selected. Capt. William Hancock surveyed the half square mile in December 1870, and the first lots were sold at the end of the month. Phoenix used the gridiron method for street patterns until the late 1930s, when the Federal Housing Administration (FHA) regulations encouraged more curvilinear models in residential areas.

By 1880, the population of Phoenix reached nearly 2,500 residents. In 1881, the city incorporated with the first elections for mayor and council. Over the next decade, a branch line of the railroad came to Phoenix, and Phoenix became the territorial capital of Arizona in 1889. The economy was heavily dependent on agriculture, which, in turn, was dependent on the sporadic and meager rainfall as there was no reliable means for storing water during times of drought. Following the passage of the Reclamation Act of 1902, Arizona became one of five recipients of funds for a reclamation project, and Roosevelt Dam was built about 80 miles east of Phoenix.

In the late teens, Phoenix's growth reflected the nation's need for agricultural products as a result of World War I, and cotton soon became the major crop. Commercial construction in particular increased. By 1920, Phoenix, now the largest city in Arizona, had the traditional components of a central core and industrial and residential areas. However, when the cotton market bottomed in late 1920, a depression resulted. Recovery was fairly rapid as farmers began to diversify crops rather than relying on one crop. With this recovery, construction began once again as marked by the rise of multistory hotels, other commercial buildings, and new residential subdivisions.

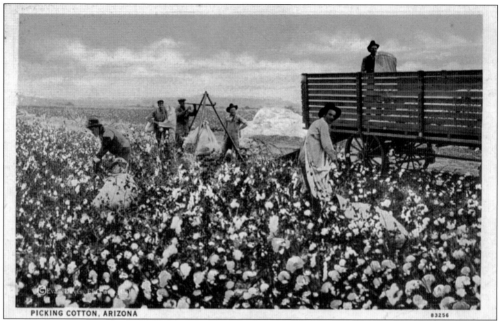

PICKING COTTON, ARIZONA 83256

Phoenix's beginnings were based on agriculture. The settlers quickly discovered that water allowed them to grow any number of crops and, in some cases, they had two growing seasons. Canals brought the water to irrigate the farms. Visitors were amazed by the groves of citrus and vast acreage of alfalfa and, later, cotton. Homeowners planted trees to shade their homes. (Courtesy of Donna Reiner.)

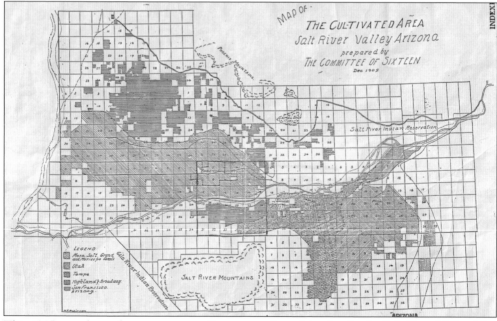

This 1905 map shows the vast amount of acreage under cultivation in the Salt River Valley. The town of Phoenix was but a small area of the agricultural picture. However, it did become the main distribution center for produce and other items between El Paso, Texas, and Los Angeles, California, by the early 1920s. (Courtesy of the Phoenix Public Library, Arizona Room.)

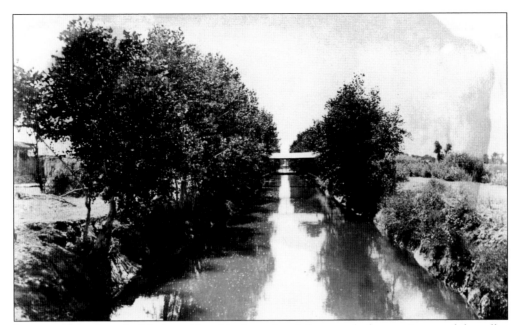

Large canals, such as the Maricopa Canal in the undated photograph above, crisscrossed the valley bringing water for humans to survive and crops to grow. The canals were part of the landscape of the Salt River Valley and provided relief from the starkness of the desert vegetation. Towering cottonwood trees lined the banks, such as seen in this photograph. The water from the large canals was then diverted into ditches, which brought the precious commodity to farms and homes. In the undated photograph below, the children are playing around the ditch water. A plank bridge crosses from the road to the house. (Both, courtesy of Salt River Project Research Archives.)

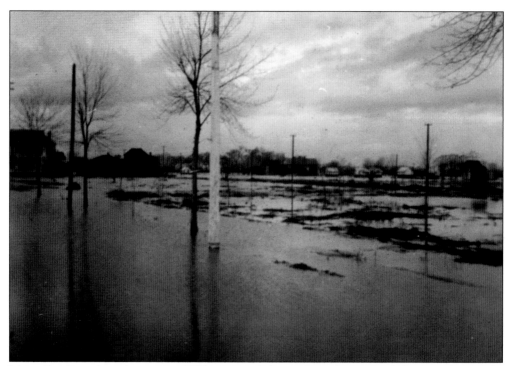

Major floods, such as this one in 1905, impacted the residential growth of Phoenix. Previously, prime property was closer to the river or south of the original townsite, but the sporadic and often devastating floods encouraged growth northward from the original townsite. Once the Roosevelt Dam was completed in 1911, flooding from the Salt River was rarely a problem. (Courtesy of Phoenix Public Library, McClintock Collection.)

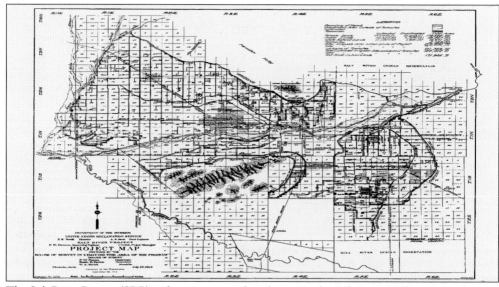

The Salt River Project (SRP) is the major provider of water to the Salt River Valley where Phoenix is located. This 1914 map shows the extensive canal system that brought the water from the Roosevelt Dam east of Phoenix. Eventually, there were three other dams built on the Salt River. (Courtesy of Salt River Project Research Archives.)

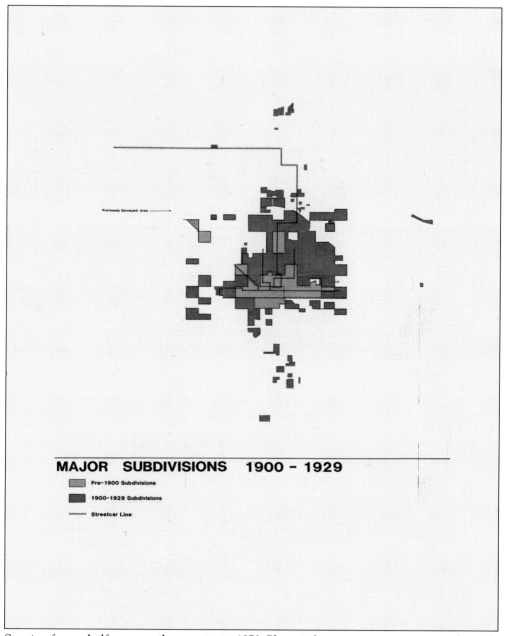

MAJOR SUBDIVISIONS 1900 - 1929

- Pre-1900 Subdivisions
- 1900-1929 Subdivisions
- ·········· Streetcar Line

Starting from a half-square-mile townsite in 1870, Phoenix began to grow in spurts in the early part of the 20th century. In most cases, large farmland acreage was sold in small parcels that were then subdivided for residential purposes. That did not mean, however, that building started immediately. Nor were the residential areas necessarily connected as is shown in this drawing. In some cases, the streetcar lines highly influenced the growth residential areas. The line on the right side heading toward a "white" square (up in the drawing) is the Brill Street Line, which terminated in Coronado. A few of the residential areas shown in this drawing were annexed by the city not too long after they were established. But most were still located in the county as of 1948. This drawing was done as part of a pre-1950 Phoenix historic residential reconnaissance survey in 1990. (Courtesy of Don W. Ryden, AIA.)

13

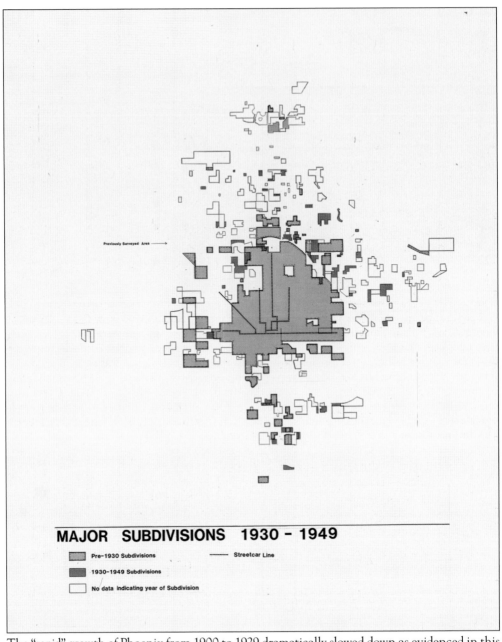

Previously Surveyed Area ⟶

MAJOR SUBDIVISIONS 1930 - 1949

▨ Pre-1930 Subdivisions ⸺ Streetcar Line

▨ 1930-1949 Subdivisions

☐ No data indicating year of Subdivision

The "rapid" growth of Phoenix from 1900 to 1929 dramatically slowed down as evidenced in this map. Looking back, it is understandable that growth radically slowed during the Great Depression. People could not afford to buy homes, but they did want a roof over their heads. Consequently, renters were the first residents in many of these small subdivisions as well as in the greater Coronado neighborhood. The growth of these small subdivisions, sometimes developer driven, continued to be hampered once World War II started. The lack of building materials forced builders to obtain special permits in order to get any supplies, and these were not always approved. No supplies, no building. Once the war ended, residential construction took off. The subdivisions with no data may be from this period and would have been located in the county rather than the city at the time. (Courtesy of Don W. Ryden, AIA.)

14

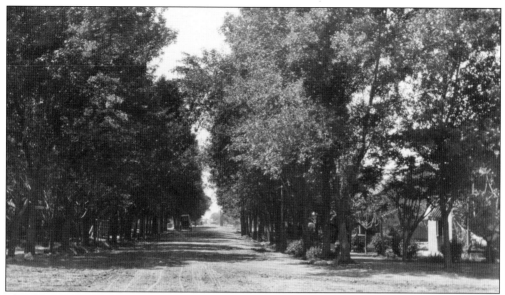

Shortly after the city's inception in 1870, Phoenix was already touting itself as "a forest city." These two pictures clearly show that trees, and rather large ones, would and did grow in the city in the desert. They provided much-needed shade and a sense of keeping the desert at bay. Certainly, the large deciduous trees reminded people of the places where they had once lived. Cottonwoods were the first ornamental tree planted in the city, but their prevalence was short lived due to their messy "cotton" debris and unwieldy roots. After mandatory removal of cottonwoods, ashes became the tree of choice. But as streets were widened, and palms became popular, most of the original trees disappeared. Today, the city has again embarked on an effort to replant trees to provide shade and reduce the current heat island effect. (Both, courtesy of Phoenix Public Library, McClintock Collection.)

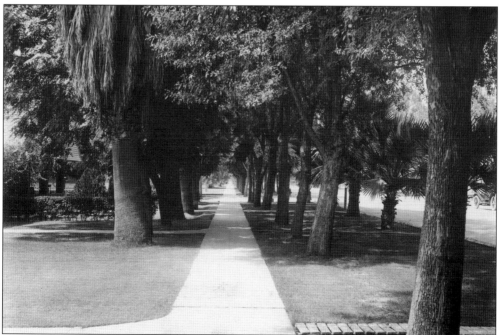

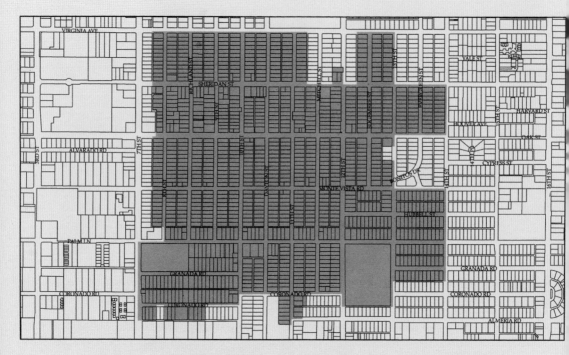

Coronado
HISTORIC DISTRICT
Phoenix Historic Property Register
February 2008

The Coronado Historic District's period of significance covers 1907 to 1942 and consists of a number of small subdivisions. Many of these were originally portions of the larger Syndicate Place, Homewood Tract, and Ranchitos Bonitos subdivisions. Construction of residences in the neighborhood generally trended from south to north and west to east. Most homes in the neighborhood are one-story. As these smaller subdivisions were not developer/architect driven, homes were constructed over a span of years. (Courtesy of the City of Phoenix Historic Preservation Office.)

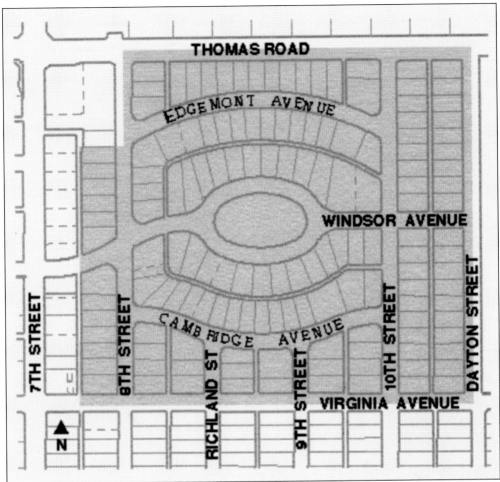

In 1939, the Aetna Investment Corporation purchased 50 acres of former dairy land for development that had been previously owned by Eleutheria Du Pont. A prime site for new building under FHA standards, the design contained curved, non-through streets, three-way intersections, and a 2.5-acre park in the center. Half of the lots were developed prior to World War II, usually with simple Ranch-style homes. By early 1942, the subdivision construction slowed due to wartime building restrictions. The Eureka Investment Company eventually took over the development of Country Club Park, hiring the local architectural firm of Lescher & Mahoney to honor the FHA uniformity guidelines. By 1946, the subdivision was complete. Ninety-seven-percent of the homes are one-story Ranches; although, one will find a few International-style houses. (Courtesy of the City of Phoenix Historic Preservation Office.)

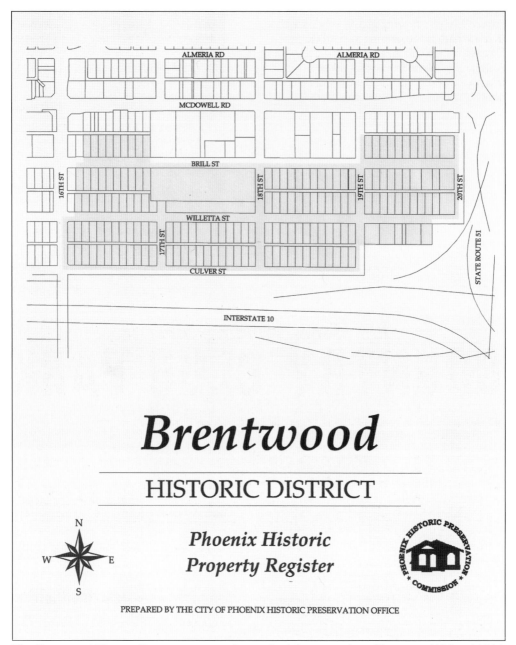

ALMERIA RD

ALMERIA RD

MCDOWELL RD

BRILL ST

16TH ST

18TH ST

19TH ST

20TH ST

WILLETTA ST

17TH ST

STATE ROUTE 51

CULVER ST

INTERSTATE 10

Brentwood

HISTORIC DISTRICT

Phoenix Historic
Property Register

N

W E

S

PREPARED BY THE CITY OF PHOENIX HISTORIC PRESERVATION OFFICE

The Brentwood Historic District consists of several subdivisions platted between 1926 and 1946. It consists of single-family residences with only four exceptions: the Latter-Day Saints (Mormon) Stake Center at 1725 East Brill Street dating from 1947 to 1949 and three small apartment buildings. Although Ranch and Period Revival houses dominate the streetscape of the district, a few Southwest and Bungalow dwellings are also found, as are a number of unstyled homes. (Courtesy of the City of Phoenix Historic Preservation Office.)

Fowler Tract is one of the small subdivisions that are part of the Coronado Historic District. When this ad appeared in the *Arizona Republican* in early October 1924, this area was still outside the Phoenix city limits. (Courtesy of the *Arizona Republic*.)

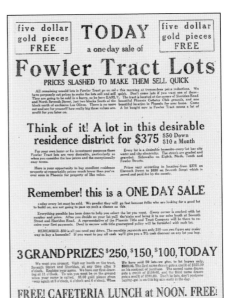

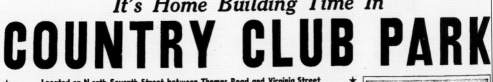

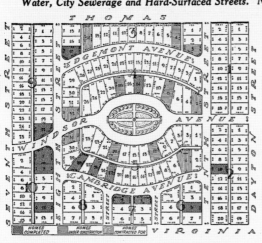

This May 25, 1941, advertisement in the *Arizona Republic* touts the merits of this new subdivision marketed by the Aetna Investment Corporation. Only two miles from the central core of the city, the developers noted that schools, service stations, a grocery store, and even a park were available to the new homeowners. Unlike the older subdivisions that make up the greater Coronado neighborhood, Country Club Park has curvilinear streets. (Courtesy of the *Arizona Republic*.)

In 1951, the City of Phoenix Planning Department had a map drawn to show the number of houses per block. This portion shows the greater Coronado neighborhood. Looking from the top left, the main road below the Country Club is Thomas Road. The major north-south roads, starting from the left, are the following: Seventh Street, Twelfth Street (dead-ends at the Country Club), Sixteenth Street, Twentieth Street (dead-ends into Thomas Road), and Twenty-fourth Street. Although it is unclear what purpose the map was intended to serve, it conveys the degree of displacement that would later occur when the Interstate 10 (between McDowell Road and Roosevelt Street) and the Interstate 51 (along Twentieth Street) were later constructed. (Courtesy of the Phoenix Public Library, Arizona Room.)

Two

THE PEOPLE AND HOMES OF CORONADO

Though not the intended legacy of the neighborhood's first working-class residents, Coronado's contemporary descriptors—"funky," "artsy," or "eclectic"—seem to have been built into the very fabric of the community. Architectural style and building materials of these homes have been influential in cultivating a creative and diverse population, who, in turn, modify the homes in unique ways. In Coronado, Period Revival architecture, known for producing creative interpretations of English "originals," was often further customized by input from homeowners. The result, even within most of the three historic districts, is a huge variation in architectural style. To walk down a single block in Coronado, one will likely see quite literally something for everyone!

Though Coronado did not begin as a cohesive or named community like some of the other subdivisions in Phoenix (for example, Encanto), the large and inclusive neighborhood boundaries have notably contributed to the diversity of residents and houses. The Coronado neighborhood is the only community in Phoenix to house sizeable numbers of homes that are both in and out of historic districts. Encompassing almost two square miles, the Coronado neighborhood houses 100 years of architectural styles, building materials, and family histories. Although each of the three historic districts contains houses constructed primarily between the 1920s to the 1940s, it is not uncommon to find 1900s farmhouses or newly constructed infill homes on each block.

As one of the early streetcar suburbs, Coronado was located close enough to downtown to be swallowed by urban growth in the 1960s and 1970s. As the residential character changed, urban flight, deteriorating housing stock, and vacant lots increased. This moment of decline created opportunity for new populations who found the petite, quirky, affordable houses a perfect match for small households, immigrant families, artists' studios, small businesses, and rentals. Diversity in house aesthetics, employment, income, race, ethnicity, religion, household size, and family type has been continuously fostered in Coronado by this ongoing exchange between people and houses. As an "ordinary" neighborhood of modest income, few are aware of the interesting range of residents in Coronado's past.

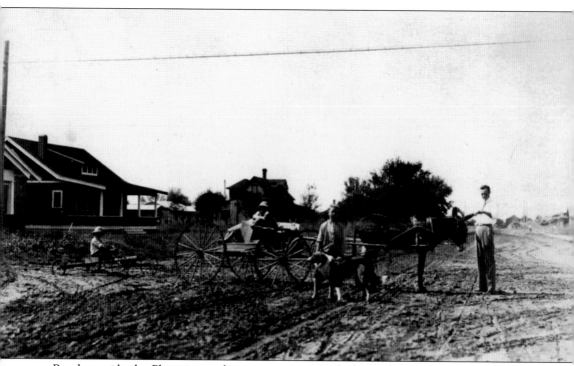

Roads outside the Phoenix city limits were not paved; although, the major roads were often graded to reduce the ruts. This view of what is presumably Seventh Street north of McDowell Road shows the rough dirt byway some time after it may have rained. The caption on the back of this early-1920s photograph reads as follows: "The kind of driving horses we see in the West. Taken in the street near our home." Charles Shoup, the man standing to the right of the animal, is not holding the ear of a horse! Was the writer making a tongue-in-cheek comment? (Courtesy of Charles Shoup III.)

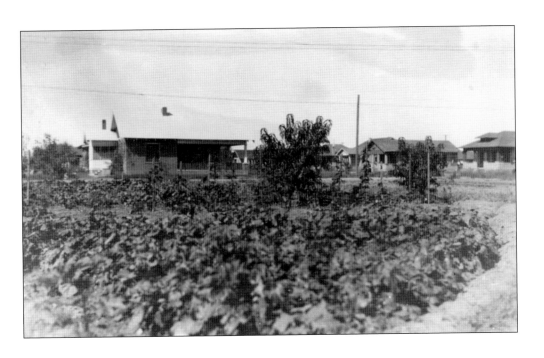

When the neighborhood was first developed, the land was outside the city limits. Agricultural water from the Little Maricopa Canal, which bisected the neighborhood along what is now Oak Street, made it easy to cultivate empty plots of land. These enterprising residents took advantage of the available lots in the neighborhood to grow some of their food and probably sell the excess. It is unclear how long they were able to "farm" the empty lots. (Both, courtesy of Charles Shoup III.)

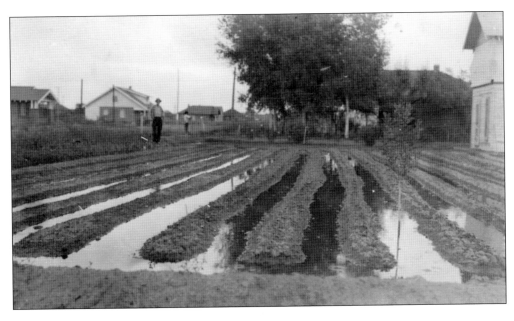

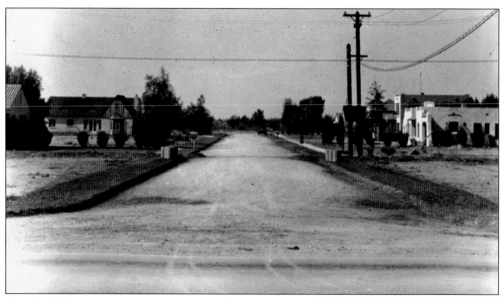

The Civil Works Administration provided the means to upgrade Sixteenth Street, then a county road. This project also gave Phoenix men a job during the difficult times of the Great Depression. Up to that time, 1934, Sixteenth Street was dirt. That meant it had to be watered periodically to reduce dust and graded following heavy rains. Taken from Sixteenth Street looking west (above), this is the view of Coronado Road showing the partial development of the area. The same perspective (below) shows Granada Road one block north. Both Granada and Coronado Roads remained dirt for several more years. (Both, courtesy of Arizona State Library, Archives and Public Records, History and Archives Division, Phoenix #98-3279 & 98-3278.)

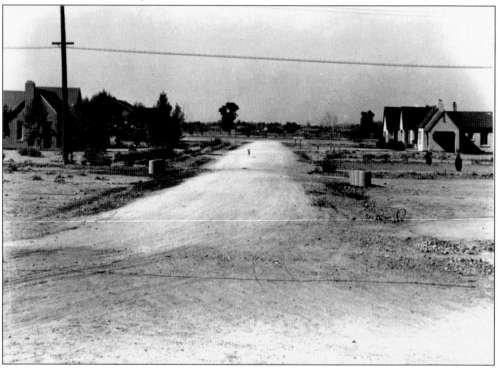

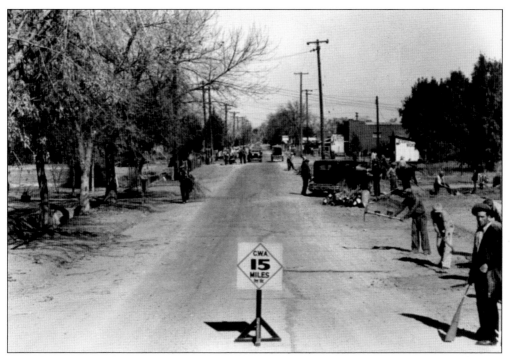

Though difficult to discern from this vantage, the primary residential structures, transportation infrastructure, and commercial practices of Sixteenth Street seen in these photographs in 1934 remain intact today. Incessantly turning tires still mark sticky asphalt, ambitious entrepreneurs seek windshield visibility, and working-class residents are housed adjacently. The canal water ditches are demarcated by the rows of trees in both of these photographs (above and below). Today, Sixteenth Street has a minimum of four lanes for traffic—a far cry from the narrow county road it once was. (Both, courtesy of Arizona State Library, Archives and Public Records, History and Archives Division, Phoenix #98-3281 & 98-3280.)

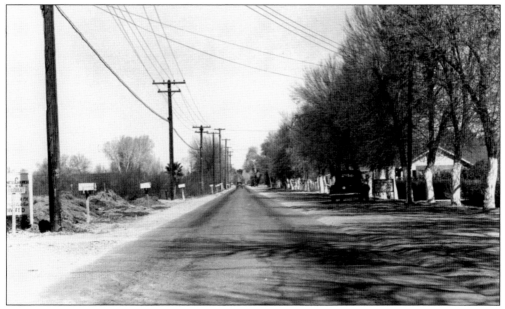

On October 16, 1931, a horrific crime was purportedly committed by Winnie Ruth Judd, a medical secretary, shown here in a trial photograph. Referred to as the "Trunk Murderess," Winnie Ruth Judd not only worked in the neighborhood at Grunow Clinic but also lived in the neighborhood. After a brief trial, she was sentenced to hang. Judd was eventually declared insane and sent to the Arizona State Asylum for the Insane, from which she escaped six times. (Courtesy of Arizona Historical Foundation.)

Winnie Ruth Judd's apartment was located at 1130 East Brill. This made for easy walking to her medical secretary's position at the Grunow Clinic at 926 East McDowell Road. Her landlord is standing in front of her apartment. The land where this small apartment complex once stood is now part of the Banner Good Samaritan Hospital complex. (Courtesy of Arizona Historical Foundation.)

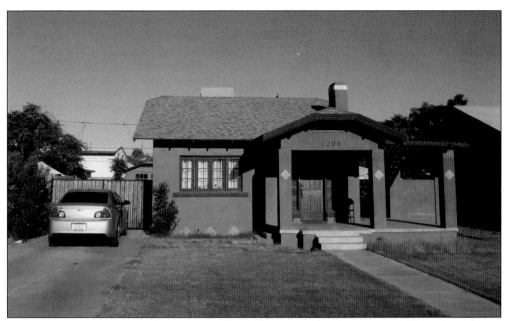

The Patrick Newton family lived in two different houses in the greater Coronado neighborhood. The house at 909 East Brill is no longer there. This one is located at 2206 North Richland Street. Wayne Newton, one of the Newton sons and now better known as "Mr. Las Vegas," attended North Phoenix High School a few blocks away. He, like many of the other teenagers in the neighborhood, often frequented MacAlpine's Drug for its soda fountain. (Photograph by David Cook.)

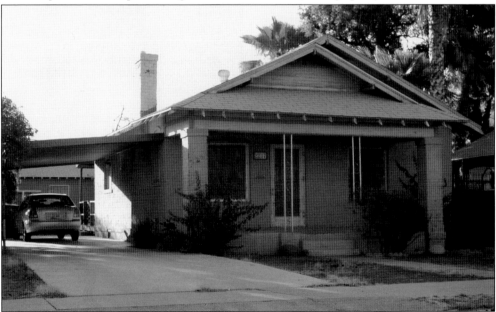

Don Carlos Driggs and his five sons started Western Building and Loan Association in 1929. This firm later became Western Savings and Loan. Two of the sons, Elwood and Douglas, lived in this house at 2217 North Eighth Street. John Driggs, son of Douglas, was the mayor of Phoenix from 1970 to 1974 and fondly remembers living in the home. John and his brother Gary were influential in local urban reinvestment projects. (Photograph by Donna Reiner.)

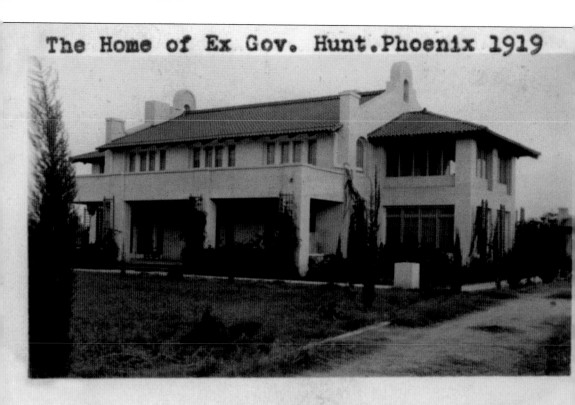

The Home of Ex Gov. Hunt. Phoenix 1919

Located at 1679 East McDowell Road, this impressive governor's "mansion" stood out from the surrounding fields along the road to the former Fort McDowell east of Phoenix. Flamboyant with his walrus mustache, Gov. George Wiley Paul Hunt, Arizona's first governor, served in both houses of the Arizona Territorial Legislature, was president of the Constitutional Convention in 1910, served seven terms as governor of Arizona, and was Ambassador to Siam under President Wilson. One small tract of land near the site of the mansion was left to Governor Hunt's daughter Virginia Hunt Frund and her aunt Lena Ellison. When the lot was subdivided, it was called the Governor Hunt Tract. The mansion was demolished in the 1950s during one of the commercialization projects along McDowell Road. Quirky even in death, Governor Hunt requested his burial in a striking white pyramid tomb in Papago Park now overlooking the Phoenix Zoo. (Courtesy of Arizona State Library, Archives and Public Records, History and Archives Division, Phoenix #09-0001.)

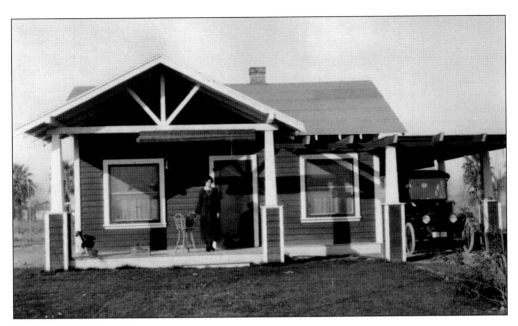

Margaret Shoup stands on the porch of 2222 North Eighth Street (above). The caption on the back of this 1923 photograph calls it "our little home." The wood frame bungalow still remains on the block. Margaret stands on the side of the house next to the sleeping porch (below). Sleeping porches were quite common elements of Phoenix homes. Only screens covered the window openings with shutters that were closed during summer monsoons or winter. Often these porches were enclosed as families expanded so the room could be used all year. (Both, courtesy of Charles Shoup III.)

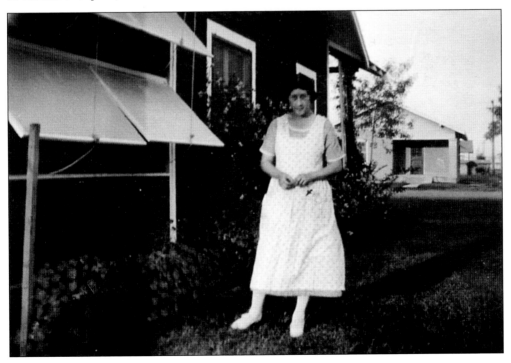

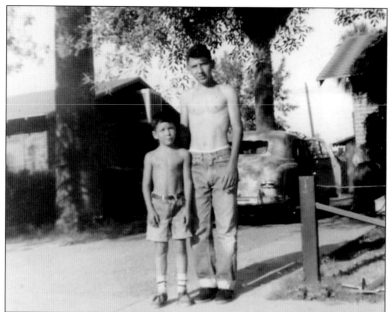

Bob Aborne and his older brother Morris stand in the driveway of their home in this undated image. Their family 1950 Kaiser Traveler is in the driveway behind them. The building in the background on the left has an evaporative cooler, a quite common feature in Phoenix in the late 1940s and early 1950s. (Courtesy of Bob Aborne.)

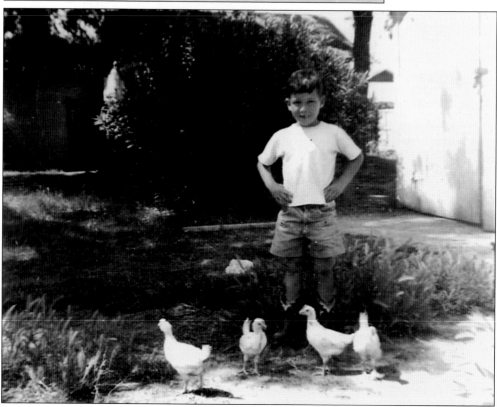

It was not uncommon for families to have a few chickens in their yards to provide fresh eggs. Bob Aborne is watching over his family's flock. Today, one can again find homes in the neighborhood where chickens provide eggs, eat garden scraps, and contribute fertilizer for gardens. This is all part of a new sustainability effort. (Courtesy of Bob Aborne.)

Boys will be boys. Bob Aborne, in the middle of the first row, and some of his neighborhood friends posed for a quick snapshot at Bob's house in this undated photograph. (Courtesy of Bob Aborne.)

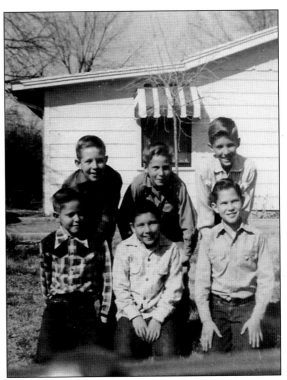

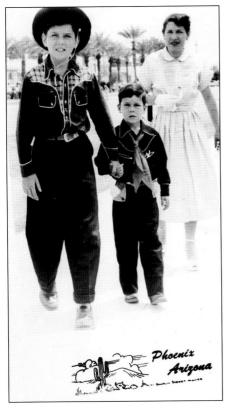

The Phoenix Jaycees sponsored the Rodeo of Rodeos from 1930 to 1998 to provide funds for its annual Christmas party for underprivileged children. A major event in the city each March, residents dressed up in their Western wear, especially if they were going downtown. The event included a parade and a rodeo. Bob Aborne, in the middle, and his older brother Morris and mother, Miriam, are prepared for the big event. (Courtesy of Bob Aborne.)

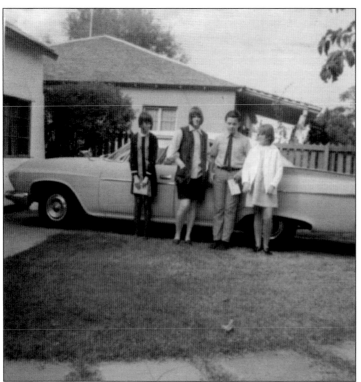

The Hendricks children, (from left to right) Reba, Carol, Roger, and Susan, are all dressed up for church in this 1960s photograph at their home near Twelfth Street and Monte Vista. They were bound for the Bible Baptist Church on Seventh Street right across from MacAlpine's. Susan says that sometimes her older siblings would ditch church to hang out at MacAlpine's. That is until they got caught. (Courtesy of Susan McDermott.)

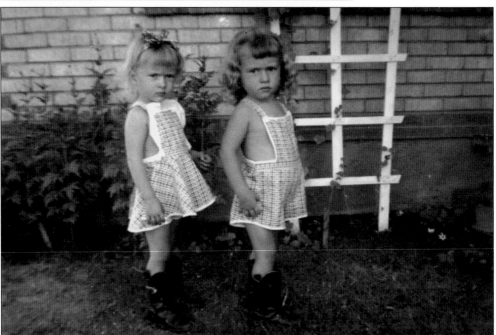

Twins Lois Elivra (left) and Lee Elverton Munsil Jr. stand in the yard by their house on 2318 North Dayton Street. Despite the need to dress functionally for the Phoenix heat, they maintain a strong fashion sense with their stylish cowboy boots. (Courtesy of the family of the late Mr. and Mrs. Lee E. Munsil Sr.)

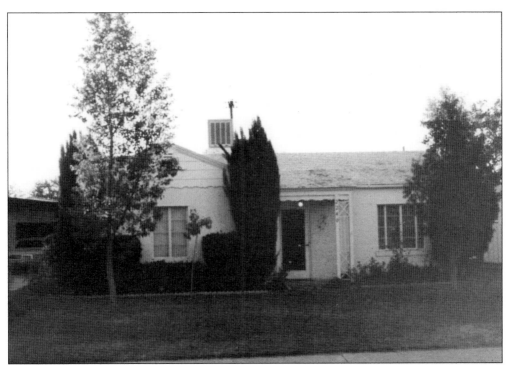

When the Cooks first moved to the neighborhood in 1977, they lived in this Ranch-style house (above) at 2240 North Evergreen Street. Then in 1984, Jerry and Marge Cook moved into this English Tudor Revival house at 1515 East Coronado Road (below). Much work has gone into remodeling the interior and improving the landscaping since that time. The house has been on the neighborhood home tour over the years due to the special care the Cooks have given to this property. The Cooks were also one of the "founding" couples of the Coronado Neighborhood Association. (Both, courtesy of Jerry and Marge Cook.)

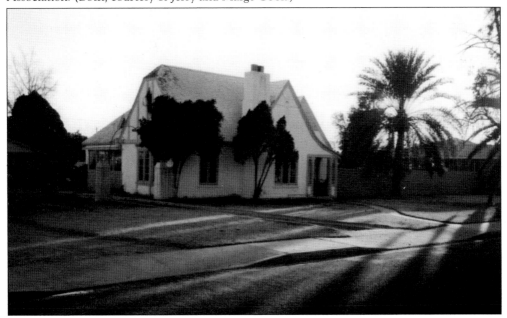

A residence from 1925 to 1944, this structure at 917 East Sheridan Street was home to the Calvary Bible Church from 1946 until 1960. During this time, the building was expanded to what is seen today. The Phoenix Children's Theatre occupied the building from 1960 to 1966. After remaining vacant for a year, the Valley Lutheran Church took over, and it eventually became known as the Valley Lutheran Indian Mission. In 1986, it took on a new life: the Arizona School of Floral Design. When the floral school left, the building sat vacant before becoming home to Sun City Sober Living, otherwise known as the Sanctuary. Today, Level 4, an architectural firm, occupies the building. (Photograph by Donna Reiner.)

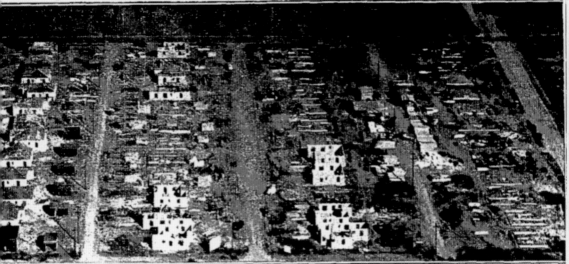

largest home building project ever undertaken in Arizona is ning momentum daily at Womack Heights, between 13th and h streets, Palm lane and Monte Vista road. The city building mits for the 53 homes, which did not include cost of land, came a total of $194,800. The ultimate cost, with landscaping and land, will be $220,000. As shown by the aerial view, the homes are being constructed on an "assembly line" basis, although each differs in architecture. The concrete men poured the foundations ahead of the brick masons and carpenters. All foundations are in. Walls are up on 24 houses. The first is to be ready within a month and the last will be completed by January 1, 1940.

Twenty-four homes in all were exclusive members of Womack Heights, which holds the claim of being the only subdivision in Coronado that was built all at once. Back in 1939, Andy Womack subdivided these two blocks of Ranchitos Bonitos, hence the name. Then, P.W. Womack Construction Company, operated by Andy and his two brothers Porter and Richard, built the homes. Womack Construction continued to build residential housing developments in the Phoenix area, particularly during World War II and into the 1950s. The firm's early large housing subdivisions predate those of John F. Long in the Maryvale area in northwest Phoenix. (Courtesy of the *Arizona Republic*.)

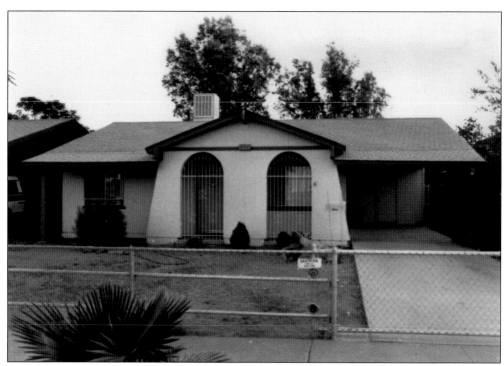

Few are aware that Coronado is home to the first urban infill development project in Phoenix. A partnership between John and Gary Driggs of Western Savings and Loan, John F. Long, and the nonprofit Neighborhood Housing Services (NHS) in 1978 resulted in the construction of 21 affordable houses on scattered vacant lots. As if to prepare the fledgling urban neighborhood for the uphill battle to overcome blight and neglect, John F. Long built only two models in Coronado: the Challenger, shown above at 1120 East Almeria, and the Champion, shown below at 2302 North Dayton Street. (Both photographs by Linda Laird, courtesy of Arizona State Historic Preservation Office.)

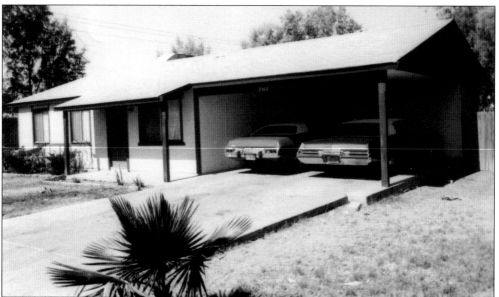

In 1986, Neighborhood Housing Services of Phoenix carried out what is believed to be the first urban renewal project to combine moving houses with "sweat equity." As part of an effort to reduce blighted vacant lots and generate affordable housing, the "Move on Rehab Experience" (MORE) relocated eight houses from the path of the Squaw Peak Parkway (SR-51) onto vacant lots in the Coronado neighborhood. Instead of a traditional down payment, the eight selected families provided 40 hours a week of labor to rehabilitate the relocated homes. Compatible in architectural style and period to the neighborhood, these eight homes are difficult to find: 2214 North Tenth Street, 2530 North Dayton Street (above), 2520 North Dayton Street (below), 2536 North Twelfth Street, 2535 North Mitchell Street, 1430 East Sheridan Street, 1431 East Yale Street, and 1435 East Yale Street. (Both photographs by David Cook.)

This undated photograph of 2564 North Tenth Street shows the front yard covered with perhaps an inch of snow (above). Phoenix experienced a heavy snowfall in late-January 1937 and again in early-February 1939. The photograph dates from one of those two times. W.E. and Normad Isaac, co-owners of the I&S Market located just a few blocks away, lived in this home a number of years. The photograph below shows the backyard of the same residence the same day (left). Snow falling and sticking was and still is an unusual phenomenon in Phoenix. (Both, courtesy of Dean Isaac.)

During the summer and before air conditioning was common in homes, Coronado residents often sat outside in the shade in order to enjoy the "cooling" breezes while kids ran through the sprinklers. Just waiting to cruise Central Avenue in the evening, a 1949 Cadillac 62 Series B sits in the driveway of the Hales' home at 2033 North Ninth Street in May 1954. (Courtesy of Barbara Prenovost.)

In the summer of 1954, young Steve Prenovost washes the 1942 Plymouth Club Coupe that his mother, Barbara, learned to drive in. It was common to see children big and small help wash the car when the temperatures went up. The hose on the ground will probably be used later to squirt the other helpers. (Courtesy of Barbara Prenovost.)

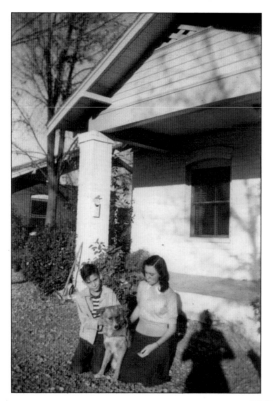

Taken in 1946, this snapshot of Barbara Hale, her brother Don, and their dog Rusty recalls neighborhood memories, such as waiting for the trolley under the ash trees on Tenth Street, fireworks at the Phoenix Country Club, pistachio ice cream at MacAlpine's, and sleeping outside in the summer. Barbara even remembers their phone number, 36070! The Hale family had been in the neighborhood two years, and Barbara had just started attending Saint Mary's High School in 1946. (Courtesy of Barbara Prenovost.)

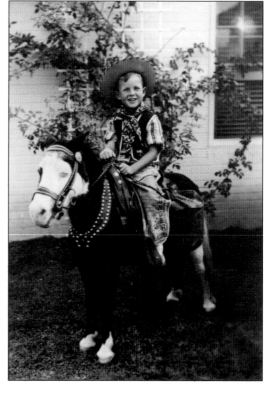

In 1946, the Robert Sebree family moved into their brand new home at 830 East Edgemont Avenue. Robert H. Sebree Jr., who was called Bobby until he married, is seen sitting on a pony in his backyard later that same year. An itinerant photographer complete with pony was taking pictures that day, and young Bobby certainly looked the part of a cowboy in his Western outfit. (Courtesy of Sally Gregg.)

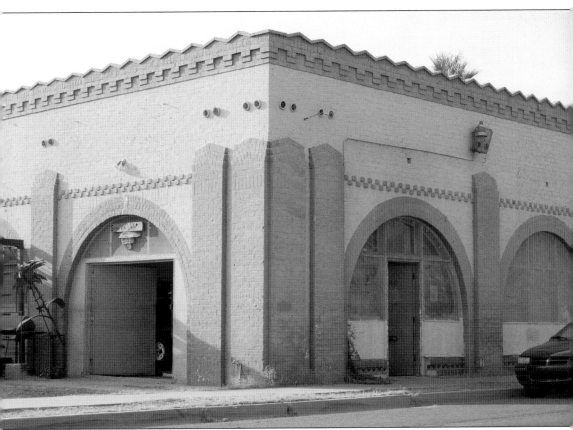

There was a small Chinese business presence on the periphery of the neighborhood starting in the late 1920s. The New Deal Market/O.D. Market, located at 1003 East Sheridan Street, dates from 1928. It was strategically located at the terminus of the Brill Street trolley car line. Tang Shing, a well-known local Chinese merchant lived in two different houses on East McDowell Road in the late 1940s and early 1950s; unfortunately, neither home still exists. Shing's Sun Mercantile Building, a major wholesale grocery established in 1929 in downtown Phoenix, is the last remaining building of Phoenix's Chinatown. Wing Ong Enterprises still owns the building at 1611 East Thomas Road, which housed Wing's Restaurant and Ong Law Office at one time. (Photograph by Donna Reiner.)

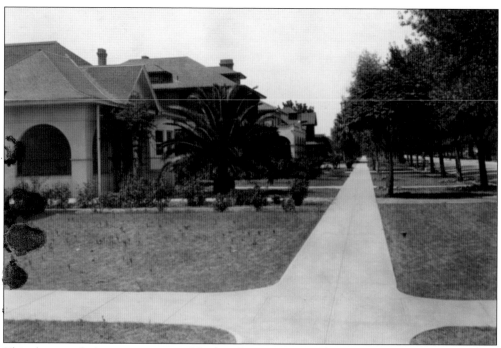

This photograph shows a mature neighborhood scene one would find in, what are now, the "older" sections of Phoenix. The homes shown here are larger than those in the Coronado neighborhood, but the landscaping is characteristic of neighborhoods in Phoenix at the time. Note the wide medians and double rows of trees. (Courtesy of the Phoenix Public Library, McClintock Collection.)

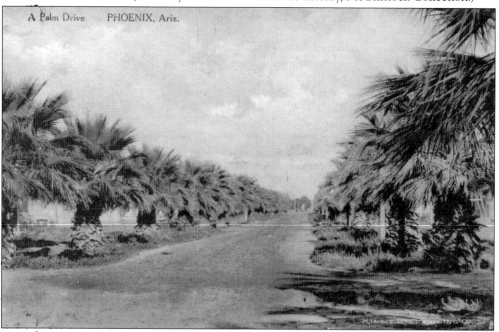

A Palm Drive PHOENIX, Ariz.

Named after the trees that lined this tidy street, Palm Lane remains a picturesque route. Today, the height of these stately palms along Palm Lane is more noticeable than any shade that they once provided. (Courtesy of Phoenix Public Library, McClintock Collection.)

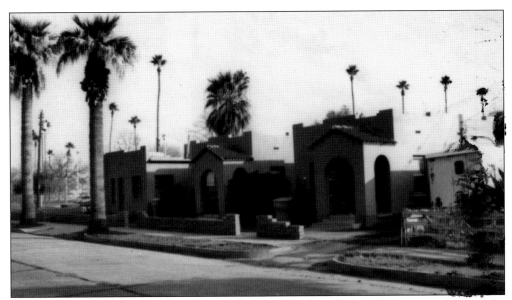

Following the mass plantings of cottonwood and ash trees in the late 1800s, palms became the signature, and enduring, ornamental tree in Phoenix. Though not the first to introduce palms to the valley, Dwight and Maie Heard are accredited with their widespread use to beautify subdivisions, including Los Olivos in 1907 and Palmcroft in 1926. This 1920s triplex, located at the intersection of Twelfth Street and Palm Lane (above), has since become a landmark in Coronado thanks to the densely planted palms and cement frogs "planted" in the 1970s (below). Driving around Coronado reveals other "palm groves," the distinctive trademark of property owners and longtime residents Wayne Murray and Mike McNulty. The majority of palms in Coronado, including those planted along Palm Lane in the 1930s, are the Desert Fan variety. (Above, photograph by Linda Laird, courtesy of Arizona State Historic Preservation Office; below, photograph by Donna Reiner.)

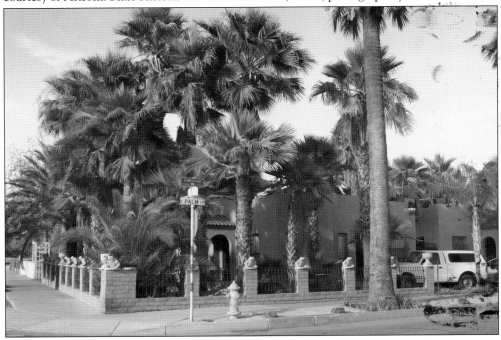

The average house in the Coronado Historic District is 1,100 square feet. Small by today's standards, owners seek creative ways to enlarge their homes and still meet the Secretary of the Interior's standards on additions to historic homes. Mark and Caren Roddy added this 700-square-foot, energy-efficient addition to the back of their 1928 bungalow. The nontraditional construction is not visible from the street. (Photograph by Maureen Rooney.)

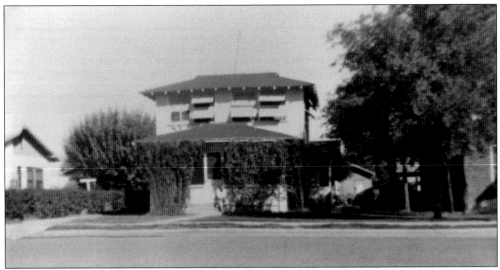

This two-story house at 2205 North Eighth Street is larger in contrast to its one-story neighbors. The second story is actually an addition that the Kent family, the original owners, needed. Note the canvas shutters on the second-story windows. (Courtesy of the Coronado Neighborhood Association.)

Frank and Verda Bentley stand in front of their house on Twelfth Street. Today, the vegetation makes it difficult to see the front of the house, but it certainly provides plenty of shade. (Courtesy of Bentley family collection.)

Taken December 7, 1941, Amy McReevee and her daughter sit on the front steps of their home at 1846 North Eleventh Street. (Courtesy of the Coronado Neighborhood Association.)

Prior to moving into a new home at 2321 North Twelfth Street in 1945, the Frank Bentley family had lived in Buckeye, Arizona. Bentley had worked on B-29 instrument panels at a plant in Goodyear, Arizona. He later took a correspondence course and became a public accountant. The above photograph shows the house when it was first built. Remodeling in 1951 included a garage and room where Bentley had his accounting office (below). (Both, courtesy of Bentley family collection.)

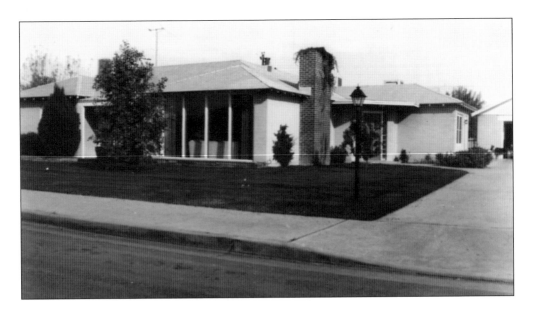

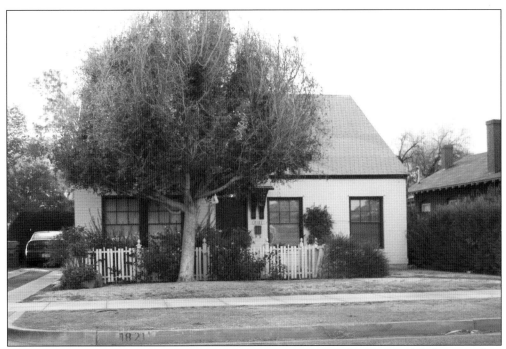

The house at 1821 North Tenth Street was the first in Phoenix with concrete-slab flooring when it was built in 1927. In 1928, homeowner William A. Warriner Jr., who worked for Riverside Cement Company, persuaded the city to pour concrete streets as part of street improvements. Warriner and his wife, Florence, lived in the house until his death in 1973. Warriner's son William A. Warriner III was in upper management of the Del Webb Corporation for a number of years. (Photograph by Donna Reiner.)

This early-1900s photograph shows one of the original farmhouses located north of McDowell Road in what was to become Coronado neighborhood. This structure and several other early farmhouses still exist. (Courtesy of the Coronado Neighborhood Association.)

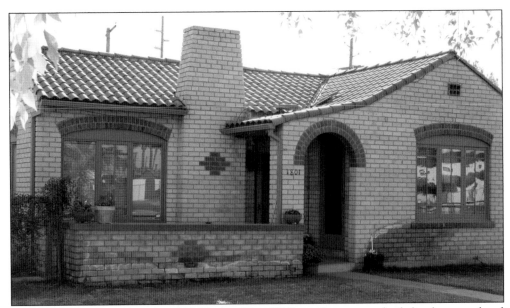

Many of the homes along the 1800 block of East Willetta Street were built by the same local developer and construction firm: Wright Davis and the Southern Arizona Development Company. This 1931 English Cottage style at 1801 East Willetta Street is one example of their work. (Photograph by Maureen Rooney.)

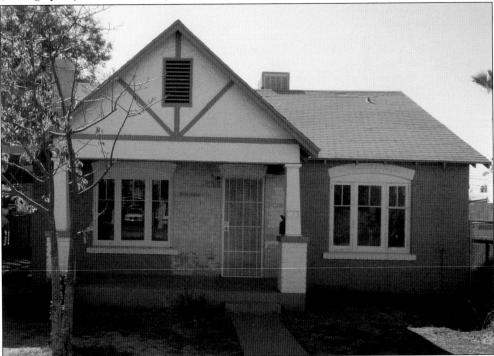

Just a few houses east of 1801 is this California Bungalow with Elizabethan attributes at 1813 East Willetta Street. From the exterior, one might not realize that the floor plan was nearly the same as the one at 1801. Also built in 1931, the first residents were renters. (Photograph by Maureen Rooney.)

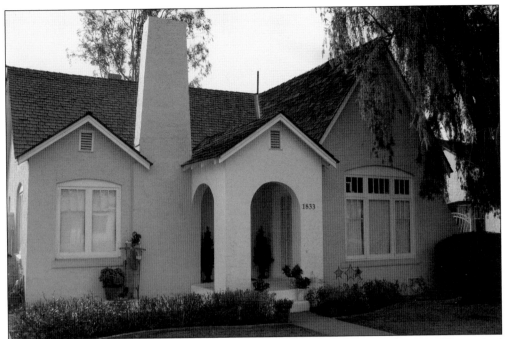

Built in 1937, this Tudor Revival home at 1833 East Willetta Street sports steep gables, arched openings on the entryway, and a grand chimney. Charles and Myrtle Herring were the first residents. Charles was the branch manager of the Tovrea Meat Packing Company, one of the largest stockyard facilities in the nation. (Photograph by Maureen Rooney.)

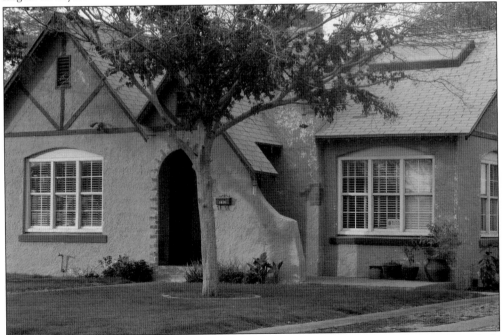

This Tudor/Elizabethan Revival home at 1820 East Culver in the Brentwood District was built in 1931 by Wright Davis. Wilfer and Frances Thomas were the first owners of the home. Thomas was a driver for Constable Ice and Fuel Company. (Photograph by Maureen Rooney.)

John Nicholas Udall and his wife, Sybil, lived in this house at 902 East Virginia Avenue. Udall, who went by Nicholas, was the 44th mayor of Phoenix from 1948 to 1952, following in the footsteps of his father, John H. Udall, who had served as mayor from 1936 to 1938. After his term as mayor, Udall served as Maricopa County superior court judge from 1952 to 1956. He practiced law until retiring in 1992. (Photograph by Donna Reiner.)

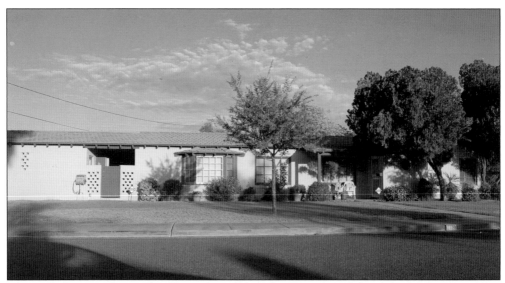

Johnny Bulla, a professional golfer and good friend of Sam Snead, lived in this house at 2720 North Tenth Street, which is now a part of the Country Club Park Historic District. Bulla "discovered" Arizona in 1938 and made Phoenix, and this house, his permanent home starting in 1946. (Photograph by Donna Reiner.)

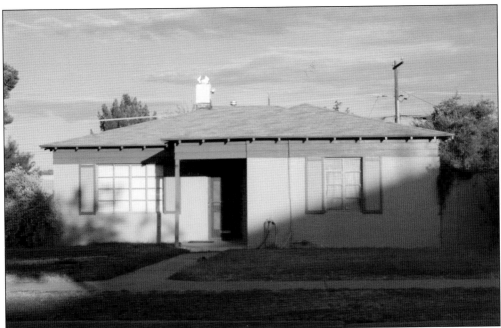

Charles S. Robb was born in Phoenix in 1939. His parents, James S. and Frances Robb, purchased this property at 2708 North Dayton Street in August 1944, built the home, and lived there until they moved to Ohio and sold the property in 1950. Charles Robb married Lynda Bird Johnson, daughter of Pres. Lyndon B. Johnson, in 1967. Eventually, Robb served as the 64th governor of the state of Virginia from 1982 to 1986 and senator from that state from 1989 to 2001. (Photograph by Donna Reiner.)

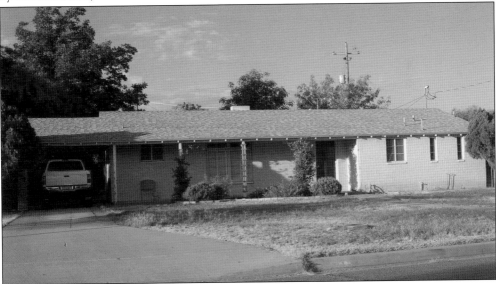

Lloyd Bimson briefly lived in this Early Ranch–style home at 813 East Windsor Avenue in the Country Club Park area. Lloyd, whose father, Walter Bimson, was president of Valley National Bank, was also involved in the banking industry. When he lived in this home, he was an assistant vice president of Valley National Bank. Bimson later went to work for Arizona Bank where he rose to the position of president in 1960. (Photograph by Donna Reiner.)

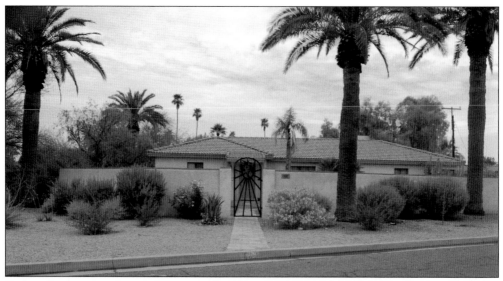

Barbara Thomason, who would become the fifth wife of actor Mickey Rooney, lived in this house at 802 East Windsor Avenue. When her parents purchased the home in July 1945, it did not have the high wall surrounding it. Barbara's father, Donald, owned Valley Furniture Store. Barbara attended North Phoenix High School just a few blocks east. (Photograph by Donna Reiner.)

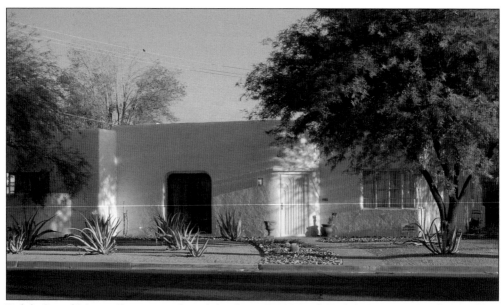

Ralph C. and Marian Barton purchased this lot at 2702 North Eighth Street in April 1940. This International-style home was one of the first houses built in Country Club Park. (Photograph by Donna Reiner.)

Walter P. McLennan Jr. was the first owner of this house at 837 East Cambridge Street. These pictures were taken in 1974 shortly after current owners Robert and June Meitz moved in. Providing some protection from the blazing summer sun, the lush vegetation hides the large Ranch-style home (above). June stands beside the backyard pool (below). (Both photographs by Robert Meitz.)

Hidden in the backyard of a house on Oak and Thirteenth Streets is this underground room. Is it a bomb shelter left over from the Cold War days or a "souped-up" root cellar? The owners are not sure either and currently use it for storage. (Photograph by Nicole Wheatcroft.)

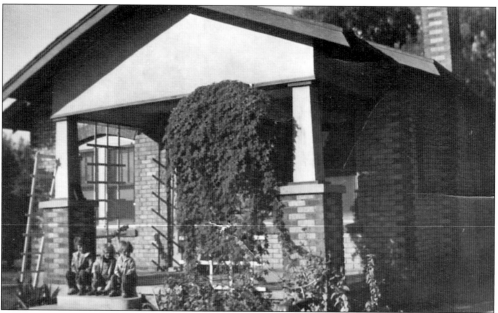

The Munsil family moved into this house at 2318 North Dayton Street in 1938, two months after their twins, Lois and Lee, were born. For 14 years, the various Munsil children played games, attended neighborhood schools, rode the trolley, and added to the life of the neighborhood. (Courtesy of the family of the late Mr. and Mrs. Lee E. Munsil Sr.)

Three

The Institutions
of Coronado

As residential development expanded away from the original Phoenix townsite, neighborhood retail buildings flourished during the first three decades of the 20th century. In Coronado, commercial structures were located along the Brill Street trolley line, along arterial roads, and scattered amidst residential blocks. Many former commercial structures still stand today in Coronado, marking this brief period before the implementation of single-use city zoning and the influence of the automobile. The legacy of interspersed commercial zoning in and on the periphery of Coronado provides much of the distinctive "real" neighborhood feel described by residents who can still walk to a corner store, doctor's office, school, or a bank.

Besides a legacy of commercial institutions along Seventh and Sixteenth Streets and McDowell and Thomas Roads, the neighborhood has been particularly influenced by social service and medical institutions. Neighborhood Housing Services (NHS), which is largely responsible for much of the neighborhood's reinvestment during the 1980s, still retains a Coronado connection on McDowell Road. Home Base Youth Center is on Thirteenth Street north of McDowell Road. Youth Empowerment Project (YEP) is on the northeast corner of Twelfth Street and McDowell Road. The Foundation for Senior Living Service is on Twelfth Street and Thomas Road while the Jewish Family and Children Services has a branch on Seventh Street. Also, the array of educational and religious institutions of Coronado have provided enumerable services to residents, including hosting performances and events, and much beautification and blight reduction volunteer work.

Today, Coronado is sandwiched between the Phoenix Children and Good Samaritan Hospitals, indicating the continued influence of medical institutions in shaping the neighborhood. The Deaconess Hospital quickly became the anchor for medical services along, what would become, the medical employment hub of "Miracle Mile." Eventually, the Deaconess became Good Samaritan Hospital. Now that site, a parking lot, is located adjacent to the new, space-age iteration. Decades of expansion and growth of Good Samaritan Hospital have influenced employment, land-use, road expansion, sight lines, and traffic in the neighborhood. The medical industry remains a large employer of Coronado residents.

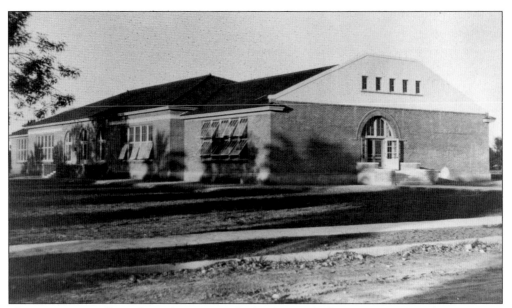

Phoenix grew rapidly in the early 1900s, and schools were built to accommodate the increasing number of students. By the early 1920s, overcrowding became a severe problem in the Phoenix Elementary School District. Emerson School was built in 1921 at the southeast corner of Seventh Street and Palm Lane to serve one portion of the Coronado neighborhood. The first Phoenix subdivision school, it needed additions by 1927 and again in 1940. (Courtesy of Phoenix Elementary School District.)

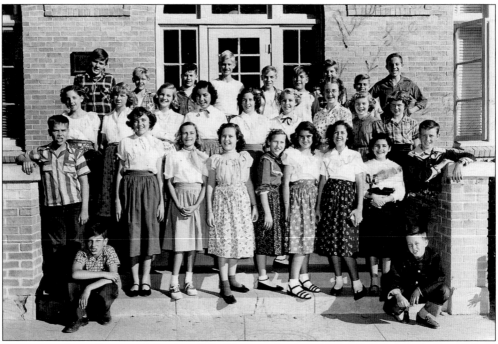

It is picture day at Emerson School in 1951. Wearing the skirt she made in home economics, Lois Munsil is the second girl from the left in the first row in her seventh-grade class. (Courtesy of the family of the late Mr. and Mrs. Lee E. Munsil Sr.)

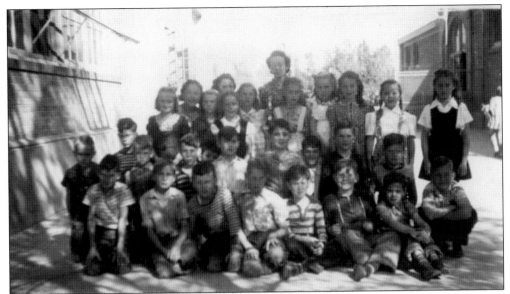

Miss Davidson's third-grade class at Emerson School posed for a picture in the school courtyard after the students won the Founder's Day birthday cake for the 1940–1941 school year. The honor was accorded to the class for having the greatest number of fathers at the meeting. (Courtesy of Phoenix Elementary School District.)

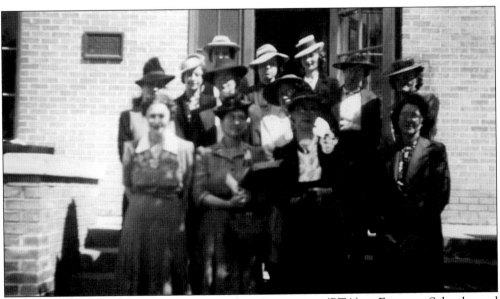

The 1940–1941 officers of the Parent Teacher Association (PTA) at Emerson School stand on the school front steps. All but one of these women is "properly" dressed with a hat. Today, the PTA is called the Parent Teacher Organization (PTO). (Courtesy of Phoenix Elementary School District.)

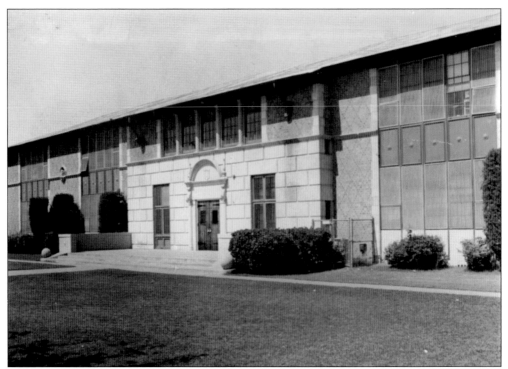

This two-story school at 2000 North Sixteenth Street was designed by the local firm of Lescher & Mahoney and built in 1929. The screens that cover the windows were not mounted when the school first opened, so this photograph was probably taken in the late 1950s. Whittier offered education from kindergarten through eighth grade. (Courtesy of Phoenix Elementary School District.)

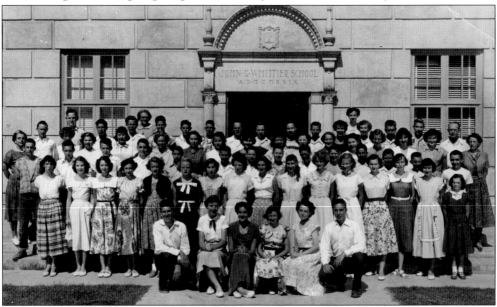

This 1951 photograph shows the entire eighth-grade class at Whittier Elementary School. The classic clothing reveals a shrug, peasant blouse, flats, and sandals. What a wonderful comparison of styles over the past 60 years. (Courtesy of Phoenix Elementary School District.)

The Junior Traffic Patrol concept in the Phoenix Elementary School District began at Emerson Elementary School in October 1940. Open only to boys at the time, the young patrolmen received 10 days of training. The intent was to make the streets safer for schoolchildren to cross. This late-1940s picture shows the Whittier School Junior Traffic Patrol members with their teacher sponsor. (Courtesy of Phoenix Elementary School District.)

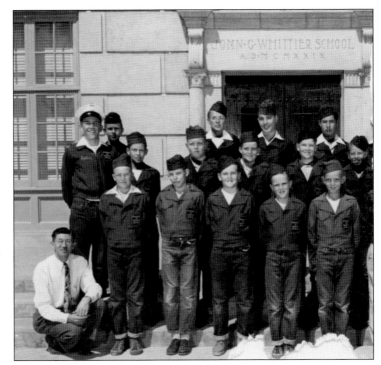

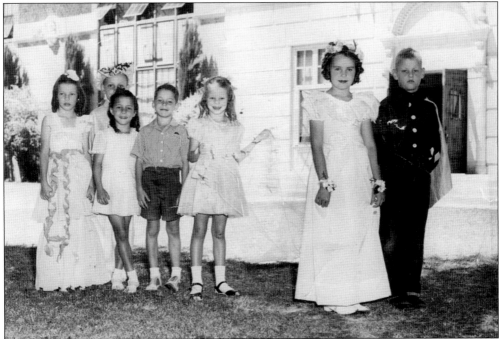

May Day celebrations were once quite common across the nation. Adults had breakfasts or teas in honor of the day. Schoolchildren often made baskets filled with flowers leaving them on the doorsteps of neighbors. These children in Marilyn Cooper's second-grade class at Whittier Elementary School are dressed for a May Day celebration in 1945. (Courtesy of Phoenix Elementary School District.)

While located outside the greater Coronado neighborhood, many of the children who lived in the western half of Coronado attended Monterey Park School (kindergarten through the fifth grade) after it opened in January 1950. This photograph above dates from the late 1950s. Each Monterey Park School graduate received a small ceramic hippo (below), the school's mascot, with the certificate of completion clutched in its mouth. Every year, the hippos came in a different color. (Above, courtesy of Phoenix Elementary School District; below, photograph by Donna Reiner.)

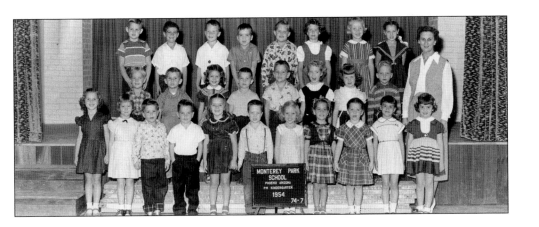

Dean Isaac, who donated the above photograph, stands fifth from the left in the second row with his 1954 kindergarten class. His mother took him to school every day, then he walked back to the family store (I&S Market) on the east side of Seventh Street when school was done. Since he and many other students had to cross busy Seventh Street at Sheridan Street, there was a familiar crossing guard who stopped the traffic for the children. The kindergarten school play (below) had fantastic costumes. Dean Isaac is standing fourth from the left in the tiger suit. (Both, courtesy of Dean Isaac.)

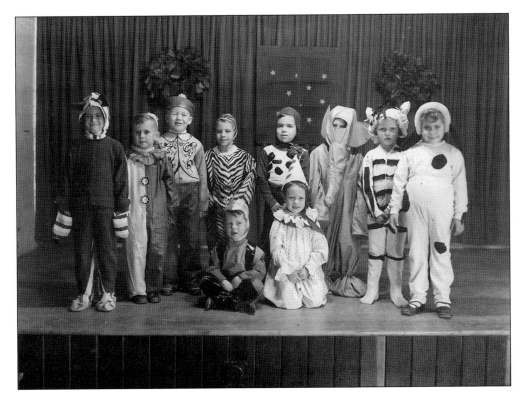

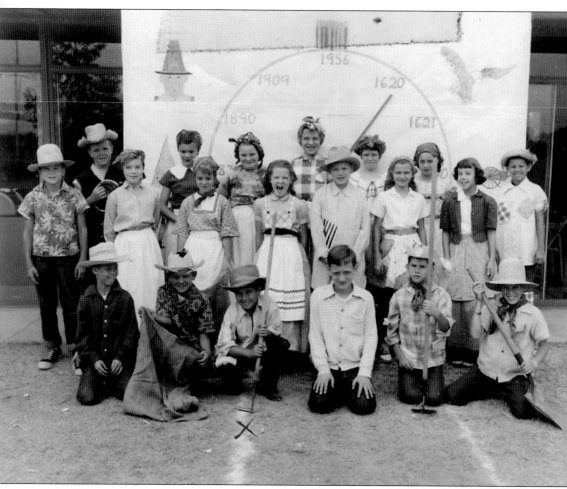

In 1956, this fifth-grade class at Monterey Park School posed in costume. The outfits have a definite Western flair despite the time line in the background, which starts in 1620. Bob Aborne is in the first row, third from the left. (Courtesy of Bob Aborne.)

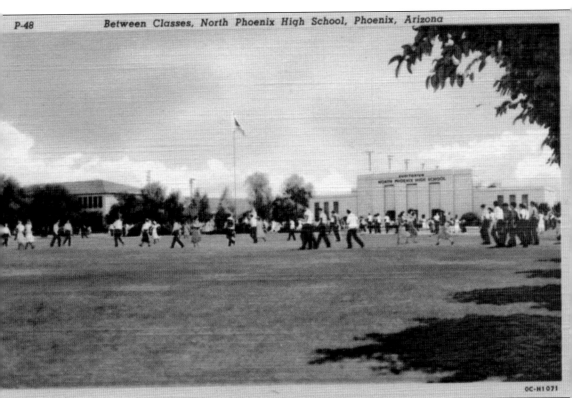

OC-H1071

Eleutheria Du Pont of the Delaware Du Ponts purchased 80 acres of land from the Pemberton family in 1918. What the widow of Henry Belin Du Pont planned to do with the land is unclear. She, however, did lease it to the Davie's Dairy for a number of years. In 1938, after much persuasion, Eleutheria sold the east 30 acres to the Phoenix Union High School District, and the remaining 50 acres continued to be used by the dairy. The deed for the sale to the high school district had a number of stipulations regarding such items as placement of the parking lot, landscaping, and the position of the cafeteria. This postcard shows the school in its early days. The additions to the school over the years blend in with the historic architecture. (Courtesy of Donna Reiner.)

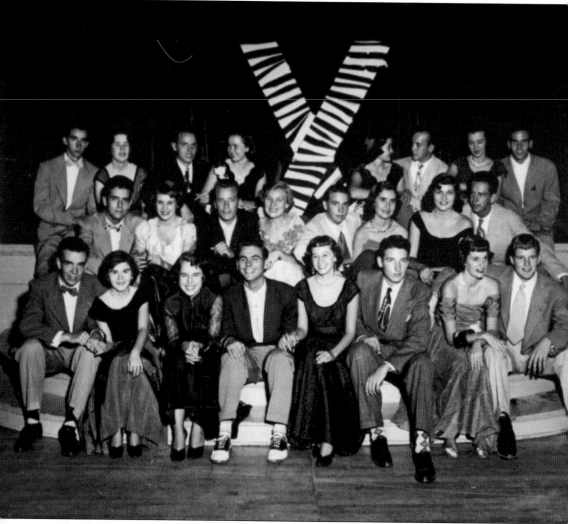

The X Club was the oldest invitational teenage organization for girls in Phoenix at the time of this undated picture. The club began during the pre–World War I days at Phoenix's Trinity Cathedral. As the organization grew, the young women held teas, dances, and other activities to raise money for charity work. Many of the city's prominent women were members during their teenage years. Patsy Koldoff, a 1951 graduate of Phoenix North High School, is fourth from the right in the first row. (Courtesy of Kim Kasper.)

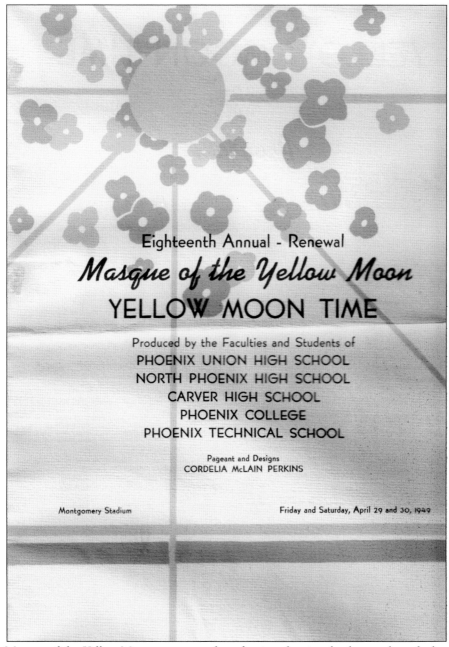

Eighteenth Annual - Renewal

Masque of the Yellow Moon

YELLOW MOON TIME

Produced by the Faculties and Students of
PHOENIX UNION HIGH SCHOOL
NORTH PHOENIX HIGH SCHOOL
CARVER HIGH SCHOOL
PHOENIX COLLEGE
PHOENIX TECHNICAL SCHOOL

Pageant and Designs
CORDELIA McLAIN PERKINS

Montgomery Stadium

Friday and Saturday, April 29 and 30, 1949

The Masque of the Yellow Moon was a grand production that involved a number of schools in Phoenix. This 1949 program indicates all the schools that participated. It was actually the first year that students from Carver High School, an all-black school, were invited. Beginning in 1926 and continuing until 1955, except for a few years during World War II, thousands of primarily high school students prepared each year to participate under the direction of Cordelia Perkins, the creator. Students learned their portion of the pageant and also assembled their own costumes. In late spring, the performers put on the masque in Montgomery Stadium at Phoenix Union High School in front of thousands of their friends, relatives, and other community members. Some attendees even drove to Phoenix from other parts of the state. (Courtesy of Kim Kasper.)

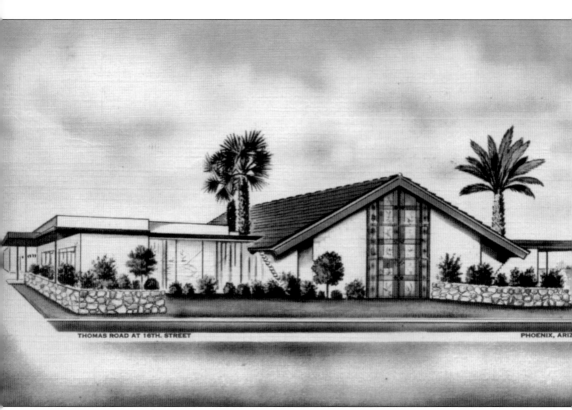

THOMAS ROAD AT 16TH. STREET

PHOENIX, ARIZ

Charles E. and Mabel Mercer founded Mercer Mortuary at 1541 East Thomas Road in 1950 with building construction completed in 1951. William Francis Cody, a well-known California mid-century modern architect, designed the building. The back of the postcard praises the design and claims that it was "one of the most beautiful mortuaries in America." When Thomas Road was widened, the grassy front was destroyed, and the sidewalk now comes very close to the chapel, completely spoiling the view that once was. The mortuary is still in operation. (Courtesy of Donna Reiner.)

Phoenix Children's Hospital began providing services in 1983 on the Good Samaritan Hospital campus (Twelfth Street and McDowell Road). In 1999, it took over a preexisting medical center located at 1919 East Thomas Road. The brightly colored buildings are visible from the Piestewa Freeway to its east. It is one of the largest children's hospitals in the United States. The postcard above shows the original buildings when it was still home to the Doctor's Hospital. The photograph below shows the hospital's expansive 2011 addition. (Above, courtesy of Donna Reiner; below, photograph by David Cook.)

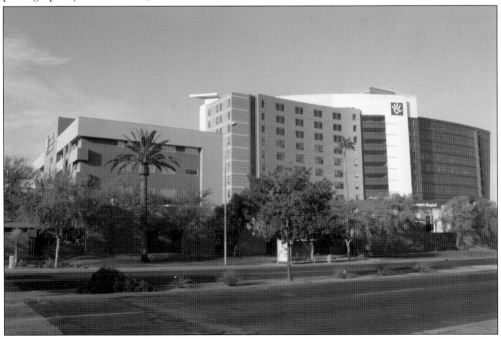

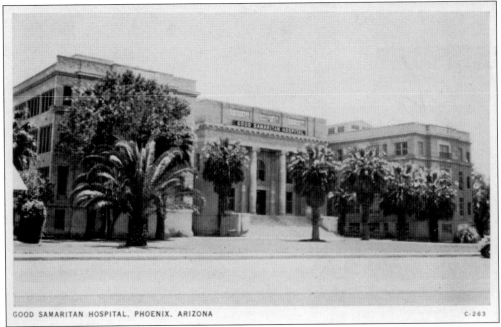

GOOD SAMARITAN HOSPITAL, PHOENIX, ARIZONA C-263

Lulu Clifton, a deaconess for the local Methodist church, founded a hospital in a rented house at 750 West Taylor in 1911. Like many others before and after her, Clifton had come to Arizona for her health. The facility was called the Arizona Deaconess Hospital and Home. In June 1923, a new and much larger building on East McDowell Road was dedicated after construction had been delayed because of World War I. Occupying the same building (above), the Deaconess Hospital changed its name to Good Samaritan Hospital in April 1928. This curvilinear tower designed by Chicago architect Bertrand Goldberg was opened in 1981 (below). Its distinctive form is visible from a distance. Today, the hospital is part of the Banner Health system. (Above, courtesy of Donna Reiner; below, photograph by Donna Reiner.)

The Grunow Clinic opened in January 1931 on the northwest corner of Tenth Street and McDowell Road (above). Designed by Fitzhugh and Byron, a local firm, the clinic was established by William and Valborg Grunow in memory of their seven-year-old daughter who died in 1929. Intended as a place to provide specialized medical care for the average-wage earner of the time, the clinic was one of the largest in the state. Winnie Ruth Judd worked there as a medical secretary, and Anne LeRoi, one of the victims in the famous 1932 "trunk murders case," was an x-ray technician at the clinic. The plateresque feature over the main door contains elements related to the history of medicine (right). The interior has a number of paintings by Lon Megargee. (Both photographs by Donna Reiner.)

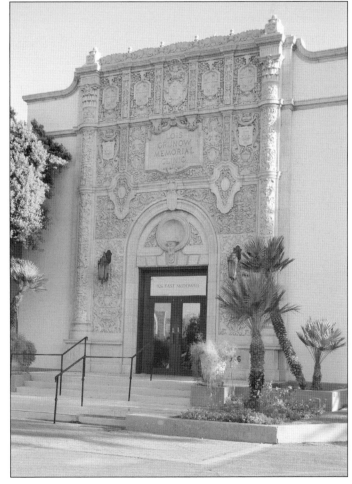

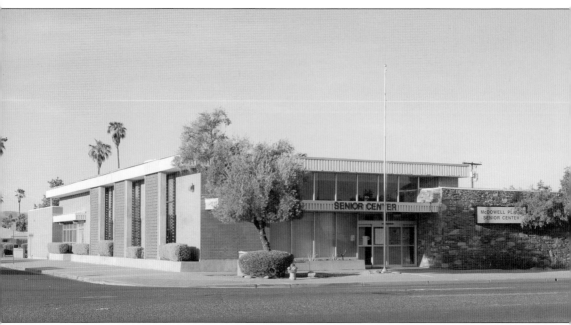

By the early 1950s, the building boom in the greater Phoenix area was in full swing. New houses brought new retail, a sure sign that more bank branches outside the downtown core were an absolute necessity to accommodate the needs of busy consumers. Valley National Bank (VNB), the largest bank in Arizona, began an expansion program in the late 1940s. The VNB branch bank on East McDowell Road, designed by the local firm of Weaver & Drover, was the 10th branch to open in Phoenix. Opening in early 1957, it served the merchants on McDowell Road and the neighbors from Brentwood and Coronado for several decades. Today, this mid-century modern building is used as a City of Phoenix Senior Center, but the original bank vaults were left in place as a reminder of the building's original function. (Photograph by Donna Reiner.)

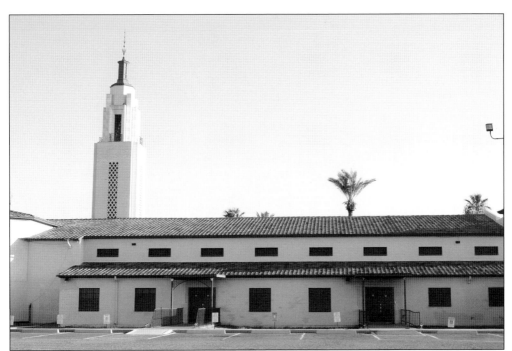

All major religious groups were represented in Phoenix before 1900. The Catholic, Presbyterian, Methodist, Episcopalian, and Baptist churches were all located within one mile of each other in the central core. Designed by Los Angeles architect Douglas W. Burton, this imposing building was built for the Church of Latter-Day Saints (LDS) in 1947 and served as the LDS Arizona East Stake Headquarters for 30 years (above). The over 22,000-square-foot facility sits on 3.5 acres. The imposing painted brick building wears complex tiled rooflines, mixing low-pitched gables with shed roofs. The decorative block on the prominent steeple evokes the Art Deco era (right). The Church of God in Christ (COGIC), the largest African American church in Arizona, became the second owner in 1978. The building serves as COGIC's state headquarters and is utilized for quarterly meetings and special gatherings. (Both photographs by Donna Reiner.)

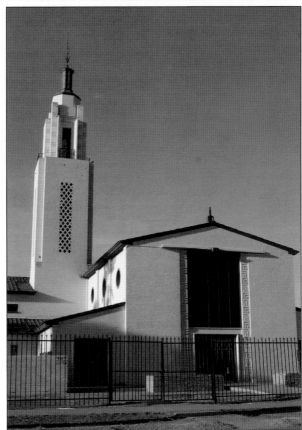

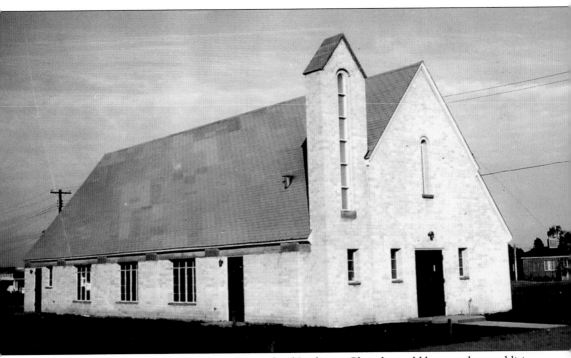

Originally built in 1946, Augustana Evangelical Lutheran Church would later undergo additions. This 1950 photograph shows the original building designed by Lescher & Mahoney. A number of early Coronado neighborhood organizers were also members of Augustana, including JoAnn Trapp, the Neighborhood Housing Services director from 1978 to 1988, and longtime residents and Coronado Neighborhood Association founders Jerry and Marge Cook. This cross-fertilization between the Coronado neighborhood and Augustana in the late 1970s and 1980s produced many fruitful results. Church volunteers aided with the Coronado historic district survey and the formation of the Coronado Neighborhood Association by hosting events and providing volunteers. (Courtesy of JoAnn Trapp.)

Tenth Anniversary

AUGUSTANA
EVANGELICAL
LUTHERAN
CHURCH

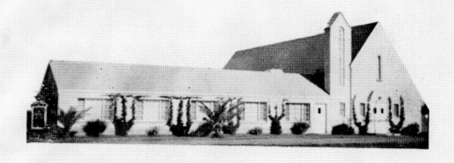

2604 NORTH 14th STREET

PHOENIX, ARIZONA

☆ ☆ ☆

HARRY L. SHOGREN, Pastor

This 10th anniversary bulletin shows the next phase of buildings at Augustana Lutheran Church. Augustana's unusually progressive social contribution to the neighborhood might just be attributed to its topsy-turvy architecture, whose resemblance to a "capsized ship" is uncanny. That portion was added in 1960. In the late 1970s, Augustana hosted a gay men's choir, a rare act at the time, even for churches in San Francisco. Today, Coronado neighborhood is one of the most diverse and gay-friendly neighborhoods in Phoenix. Augustana Church is presently home to Church of God in Christ, Arizona's largest African American network of churches. (Courtesy of JoAnn Trapp.)

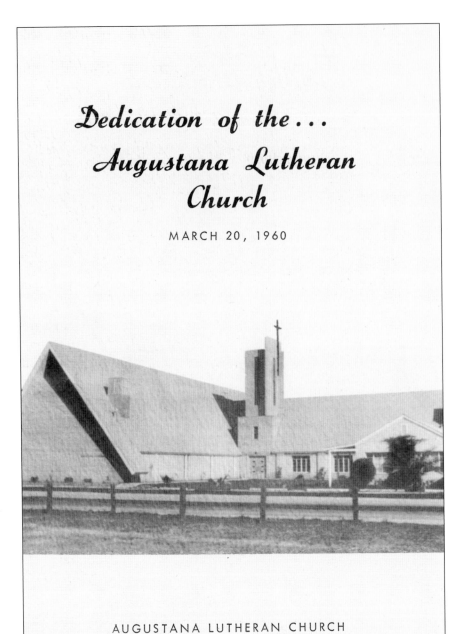

Dedication of the...
Augustana Lutheran
Church

MARCH 20, 1960

AUGUSTANA LUTHERAN CHURCH
2604 N. 14th St. Phoenix, Arizona

The distinctive roof of Augustana Lutheran Church (the left hand portion of the building in this dedication bulletin), located at Fourteenth Street and Virginia Avenue, was innovative when it was built in 1960. Early construction photographs might call to mind a large, but simple A-frame building. However, it is what is not seen that is unusual. The architect for this section, Richard O. Nelson, specified something called Tim-Deck. These were four-by-six units of Douglas fir cut in six-foot and 21-foot lengths, double tongue-and-groove pieces, which were supported by laminated trusses. Eight-inch spikes held the wood in place, and this decking was then covered with asbestos shingles. (Courtesy of JoAnn Trapp.)

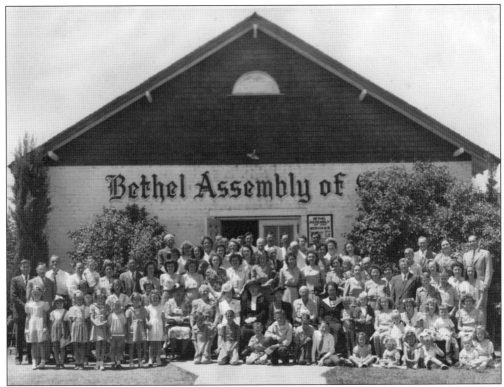

This 1946 photograph shows the congregation of the Bethel Assembly of God located at 2300 North Ninth Street. Evangelist William A. Ward is on the extreme right in the back row. Brother and Sister Charles Green, pastors, are standing to the left of Ward. This building, located on the northwest corner of Ninth and Oak Streets, is now both ashram and *gurdwara* for the Sikhs. (Courtesy of Ron Heberlee.)

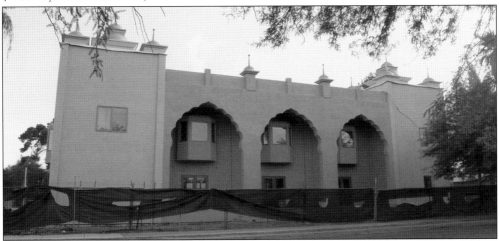

This Sikh temple, or *gurdwara*, is on the northeast corner of Oak and Richland Streets. Not yet completed, the building has been under construction for a number of years. The gurdwara pictured here with striking gold painted domes sits just west of the current ashram and is a landmark for the community. The greater Coronado neighborhood is home to two ashrams, although this one services the larger of the two. (Photograph by Donna Reiner.)

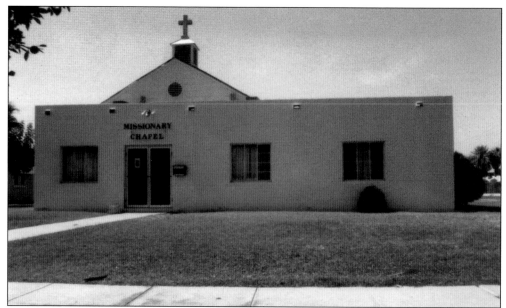

Like the church formerly at 917 East Sheridan Street, this building started off as a house. A number of churches have called this building home through the years. Today, it is home to the Missionary Chapel, which primarily provides services in Spanish. (Photograph by Linda Laird, courtesy of Arizona State Historic Preservation Office.)

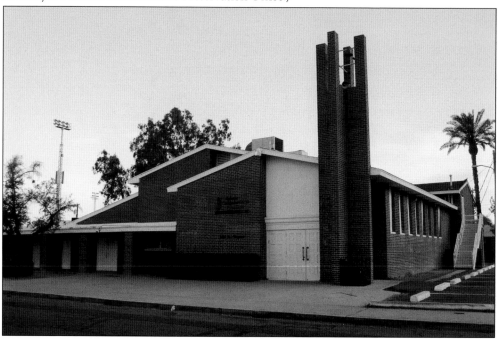

Covenant Presbyterian Church, located on the northeast corner of Twelfth Street and Virginia Avenue, opened in 1951. The Covenant Presbyterian congregation had periodically combined activities with Augustana Lutheran Church, located just at the east end of the block. The building is now home to the Iglesia Compañerismo Cristiano congregation with most services held in Spanish. (Photograph by Donna Reiner.)

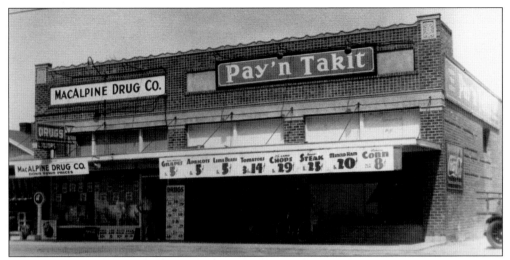

Taken around 1939, this exterior shot shows MacAlpine's Drug owned by Fred "Mac" MacAlpine. This may have been the last year of the Pay 'n Takit grocery on the right side of the building. A landmark building in the neighborhood, it is located on the northeast corner of Oak and Seventh Streets. Today, it is larger, having been expanded on the north side in the late 1940s. (Courtesy of Monica Heizenrader.)

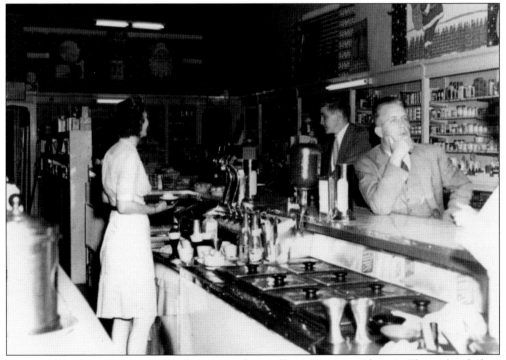

The counter, shown in this undated photograph, is still active in MacAlpine's. The malts, shakes, banana splits, sodas, and all the other accoutrements associated with a soda fountain attract people from around the valley and across the continent. There's even a working jukebox. The drugstore has not existed since December 1991, but when the current owners took over the entire building in 2001, they decided to offer vintage clothing and furniture to tantalize shoppers. (Courtesy of Monica Heizenrader.)

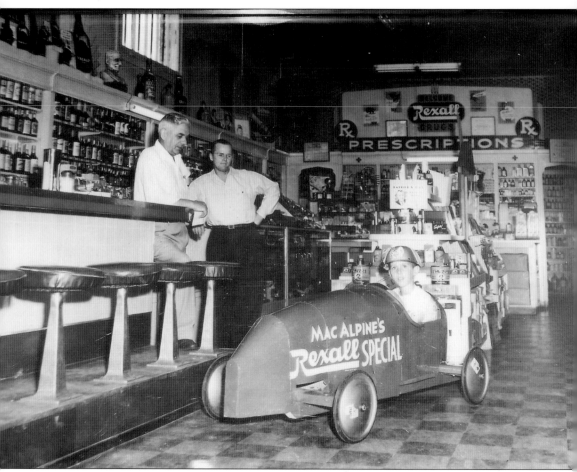

Any good neighborhood business would sponsor various youth activities as part of marketing efforts. Besides the usual little-league team, MacAlpine's also sponsored a soapbox car racer in the mid-1940s. Hal, the driver, lived with his parents, Marion and Katherine Bonham, at 2237 North Richland Street, just two blocks east of MacAlpine's. Hal mowed the lawn for Mary Ellen MacAlpine. She brought Hal's interest in needing a sponsor for the derby to her husband, Mac, when the soapbox derby season came around that year. Today, MacAlpine's continues the legacy of generosity by sponsoring multiple youth and Coronado-related endeavors. (Courtesy of Hal Bonham.)

The I&S Market was owned by Elwood and Normad Isaac, pictured here with their son Dean (above). Normad's aunt and uncle, Beth and Earl "Sandy" Sanderhoff, were the co-owners. The two couples bought the store in July 1950 and owned it until June 1974. I&S was located at Seventh and Oak Streets in the south half of the building that also housed MacAlpine's Drug. The Isaacs and Sanderhoffs had previously owned a grocery at Friendly Corners south of Eloy, Arizona, and also the Country Club Market at Seventh Street and Osborn Road, about a mile north of this store. A typical interior of a small market with Santa pitching a product is shown below. (Both, courtesy of Dean Isaac.)

While they did not live in the neighborhood, co-owners Pauline "Beth" and Sandy Sanderhoff were fixtures at the I&S Market. They are standing in front of the store in this undated picture. Sandy, born in Michigan, came to Phoenix via Los Angeles in 1917. He started off working for the Phoenix National Bank and then transferred to the First National Bank of Arizona. Eventually, he moved into the grocery store business. Beth's family had lived in Arizona before it was granted statehood. Sandy died in 1972; Beth died in 1994. (Courtesy of Dean Isaac.)

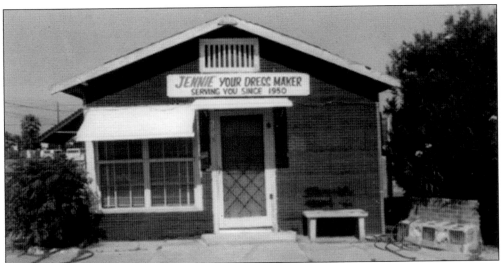

Samuel Sellers and his wife, Ruby, purchased the property in the late 1920s and built this wood frame house at 2304 North Twelfth Street. Samuel, Ruby, and their three children lived in the house until 1950. From then until it was demolished in the late 1980s or early 1990s, it housed a laundry and then this dressmaker's shop. This parcel is now part of the parking lot for Sunshine Market. (Photograph by Linda Laird, courtesy of Arizona State Historic Preservation Office.)

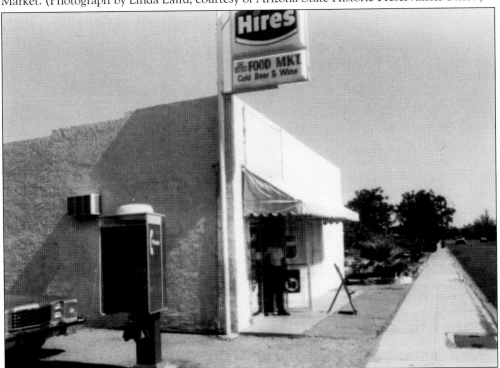

Long a fixture in the neighborhood, this corner grocery at the northwest corner of Twelfth and Oak Streets has had a variety of names. To many old-timers, it was Yoakum's. Today, it is the Sunshine Market. No matter the name or the owner, the market has provided a necessary service for the neighborhood. (Photograph by Linda Laird, courtesy of Arizona State Historic Preservation Office.)

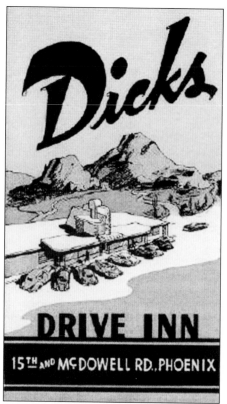

Dick's Drive Inn, located at 1438 East McDowell Road, opened in late 1948 or early 1949. Owners Richard Ames and Max Vander Bilt operated this wildly popular hangout until 1960. Vander Bilt actually lived in the Coronado area at 1514 East Almeria, within easy walking distance of his establishment. (Courtesy of Ron Heberlee.)

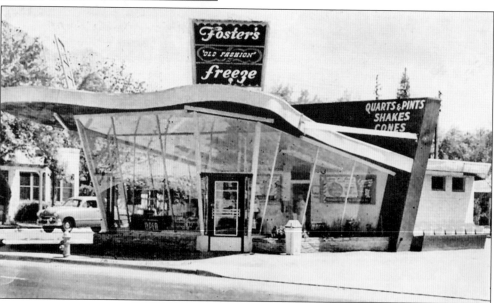

Foster's Freeze, as seen in this 1952 photograph, was one of the earliest chain fast-food businesses on East McDowell Road. Located at 1151 East McDowell Road, the business was there for a mere 10 years. Owner Hess Trader lived close by at 1516 North Twelfth Street just south of McDowell Road. Prime commercial property, the land where this restaurant once stood is now part of the Banner Good Samaritan Hospital complex. (Courtesy of Ron Heberlee.)

As the city had expanded (in 1948, the northern city limit was at Thomas Road), there was an urgent need to provide better fire coverage to residents. Phoenix Fire Station No. 5 opened around 1950–1951 at 1401 East Thomas Road. In 1967, the crew members put out a small blaze on one of their trucks parked behind the station. By the early 1980s, modernization of equipment meant that larger stations were more efficient, so Station No. 5 moved to a shiny new home. This building is currently empty; although, several entities have been housed there since the firehouse days. Prior to the construction of this station, a house stood on this property for nearly 10 years. (Photograph by Donna Reiner.)

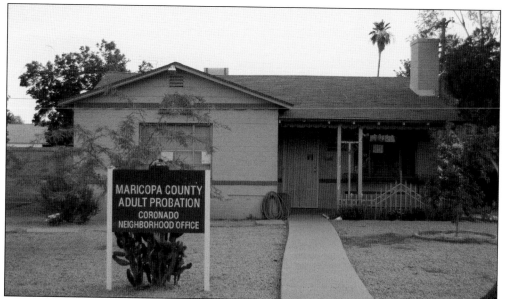

The Maricopa County Probation Office, located at 1210 East Virginia Avenue, resides in a small former residence, which was part of the Covenant Presbyterian Church property. The satellite office is an outgrowth of the community policing efforts, which were part of the Comprehensive Community Program grant awarded to the neighborhood in 1995. The back section of the building houses the office of the Coronado Neighborhood Association; the backyard is home to the association's community garden. (Photograph by Donna Reiner.)

This undated photograph of Officer Jack Ashley was taken near I&S Market on Seventh and Oak Streets. Ashley was known as the "magic cop" by thousands of Phoenix schoolchildren because he did magic tricks while explaining traffic safety to them. Ashley also had a program for 11 years on KPHO TV called *Wanted*. Jack and his wife, Bea, owned Ashley's Five and Ten, which was located in the 1948 addition of the MacAlpine's Drug building from 1949 to 1959. (Courtesy of Dean Isaac.)

Four

CREATIVE SPACES OF CORONADO

Take into consideration Coronado's legacy of affordable rent; array of social service institutions and community organizing; and the population of creative, diverse residents, it is no wonder the neighborhood is home to a plethora of creative spaces. It is difficult to drive down a single street in Coronado without spying evidence of some sort of creative endeavor: an art, architecture, music, or design studio or small business; a mural or sculpture; and flyers for a performance, festival, or exhibition.

Much of the community organizing during the 1980s by Neighborhood Housing Services and the Coronado Neighborhood Association (first meeting in 1986, incorporated in 1988) involved themed fairs and festivals because so many of the active residents were themselves involved in artistic pursuits. The Society for Creative Anachronism, an organization dedicated to preserving the arts and skills of pre-17th-century England, was so popular in Coronado during this time it was considered its own medieval territory.

By the 1990s, Coronado residents were pursuing, and earning, large community improvement grants that supported creative infrastructure. In 1995, the neighborhood received a $1.5-million Comprehensive Community Program (CCP) grant from the Department of Justice, and of that total amount, $11,000 sponsored 10 murals to beautify the neighborhood, encourage residents to maintain their properties, and stop graffiti. Most recently, Sixteenth Street business owners, residents, and artists have formed Calle 16, a nonprofit organization dedicated to supporting community through murals. Two decades of support for murals have set the stage for Coronado to become the city's mural district.

What became known as Coronado Renaissance Faire was first held on Augustana Church grounds in June 1983 to commemorate the 500th anniversary of Martin Luther's birth. Initially, this was a one-day affair. By 1987, it moved to Coronado Park to accommodate the growing crowd, spanned two days, and was celebrated in October when the weather was cooler. Eventually, the Coronado Renaissance Faire moved out of the neighborhood and continues to this day. JoAnn Trapp (left), the director of the nonprofit Neighborhood Housing Services, is in costume in her booth. A local neighborhood recorder group provided some of the music (below). (Both, courtesy of Jerry and Marge Cook.)

Musica Dulce, a professional music group that formed in 1978, performed at the Coronado Renaissance Faire in the 1980s (above). It was only natural to ask them to be a part of this new event since the group's focus was Medieval, Renaissance, and Baroque music. Attendees and participants alike enjoyed the Renaissance atmosphere despite the Phoenix heat (right). Each year, the costumes became more detailed, and even many of those who came to participate in all the activities dressed accordingly. (Both, courtesy of Jerry and Marge Cook.)

ACT1 was the Augustana Community Theatre program held at the Augustana Lutheran Church. This intergenerational community theater produced a number of dramas and musicals under the leadership of the daughter of the church's first pastor. *Under the Gaslight* (above) and *Godspell* (below) were two of the productions performed in the 1980s. (Both, courtesy of Jerry and Marge Cook.)

Childrens' Theater Is Ahead

es your youngster like to all dressed up in Mommy daddy's clothes, and put on ginary pageants?

there a teenager in the ly who's forever turning g room or patio into a e for little plays starring nimates and neighborhood ds?

so, circle Tuesday eve- g on your calendar and ke a note of this address: rch Building, 917 E. Sheri-...

here, at 8 p.m. each Tues-

CLUB TO MEET

e Mortar Board Alumnae , organized this winter at a ting held at Arizona State versity, will meet at 8 p.m., day, at the home of Mrs. Kemp, 709 Vista Del o, Tempe.

day, persons interested in organizing a Children's Theater in Phoenix will meet to discuss the project and take steps toward getting it established.

According to Mrs. Malcolm Lind, executive secretary, the theater will serve Phoenix and the surrounding area on a non-profit basis.

"Its purpose," she states, "is to provide a place where children from 6 to 16 may be competently directed in theatrical crafts, participate in productions, and work in creative dramatics.

"In addition to presenting entertainment for young citizens, it will promote appreciation of, and familiarity with arts related to the drama—good literature, music, and dancing.

"All children in the 6-to-16

age bracket will be eligible to participate at no charge."

A permanent board of trustees, consisting of 30 members, will elect officers and direct the theater's activities, Mrs. Lind explained.

Three types of membership will be established.

Patron ($100 per year), which will entitle a member to two voting memberships and four season tickets; Sustaining ($25 annually), which will carry the privilege of one voting membership and two season tickets; and Subscribing ($10 annually), with one voting membership and one season ticket.

Mrs. Miles Thorpe is treasurer of the organization.

Standing committee chairmen are: Mmes. Stephen Demos, organization, membership, and promotion; Thorpe, budget, finance, and legal; Warren Fisher, program and education; Zane F. Folk, productions; Joseph E. Stumpf, chaperones and auxiliary; and L. D. Reed, box office tickets and clerical.

BLEMISHES—

Canon George Ray Aids Children's Theater
Mrs. Stephen J. Demos, Left, And Mrs. Arnold H. Abelson

This March 1960 article details the start of the Phoenix Children's Theater (PCT) in a former church building at 917 East Sheridan Street. Betty Bimson, wife of Earl Bimson Jr. of Valley National Bank, was very involved in founding and helping to sponsor this organization. The approach of the theater was unique in that it featured children playing all of the roles in the plays. During its operation, the theater was also home to the Rabbits in Our Hat (RIOH) Magic Club. The RIOH featured young people, primarily teens, as the performers. Hundreds of kids went through the Phoenix Children's Theater in its short, but productive, life. A small group of former PCT alumni meet weekly at a local coffee house. (Courtesy of the *Arizona Republic*.)

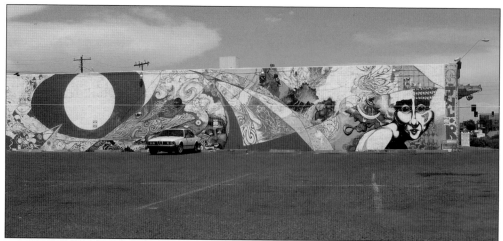

Artists Joerael Elliott and Jesus Rodriquez created this mural on the west side of Hair Pollution (formerly Way Cool) at 1524 East McDowell Road. The artists worked for well over a year as the piece developed across the wall. Owner Tad Caldwell is a strong supporter of art both in his salon and the community. A rotating body of work of local artists is always featured inside the salon. (Photograph by Maureen Rooney.)

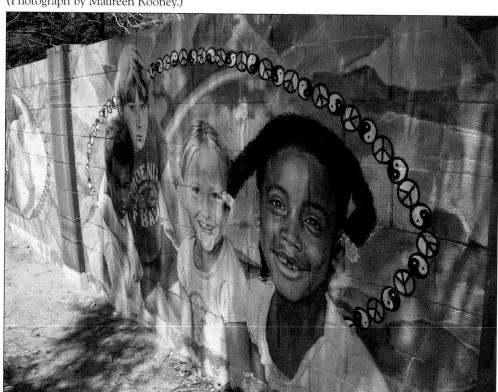

A large and very blank block wall along Seventh Street near Coronado Road cried out to Maggie Keane, a Coronado resident and painter for years. When her son enrolled in the school that owned the wall, she persuaded the director to allow her to spruce it up. Using photographs from the school's albums, Maggie put together an eight-panel collage in 2003–2004. Children from the school helped with the flag panel. (Photograph by Maureen Rooney.)

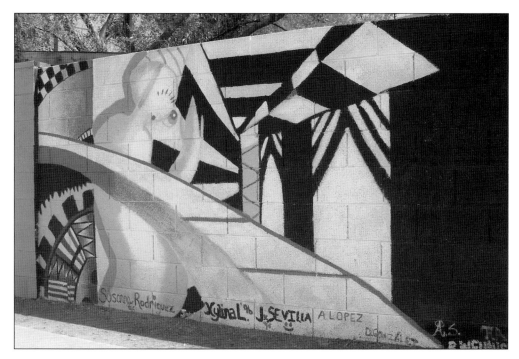

As part of the Comprehensive Community Program (CCP), North Phoenix High School art students spent the summer of 1998 painting six panels on the block walls of private homes along the south side of Virginia Avenue south of their school. Two of the panels have survived (shown here in 2007), while new panels have also appeared. The mural panels do seem to deter "tagging." (Both photographs by Maureen Rooney.)

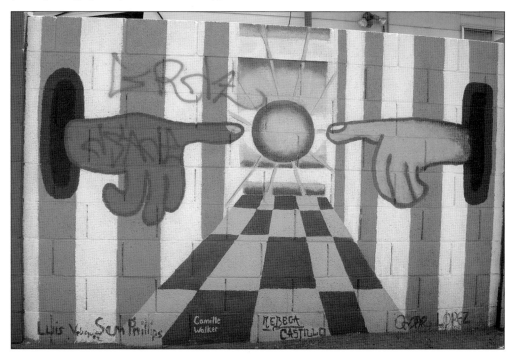

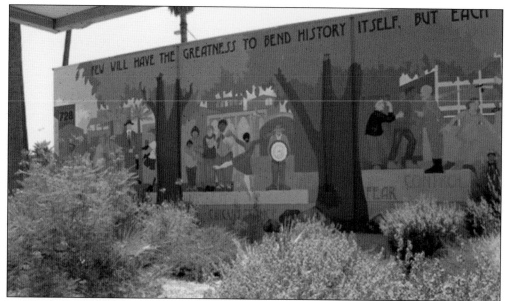

Artist Angela Cazel-Jahn used Robert F. Kennedy's quote as the inspiration for her mural on the east wall of Summit High School, located at 728 East McDowell Road. Cazel-Jahn invited members of the neighborhood to assist with painting the mural, which was part of the 1998 CCP. The best view of the work is from the Sonic Drive-in east of the school. The quote reads, "Few will have the greatness to bend history itself, but each of us can work to change a small portion of events. It is from numberless acts of courage and belief that human history is shaped." (Photograph by Maureen Rooney.)

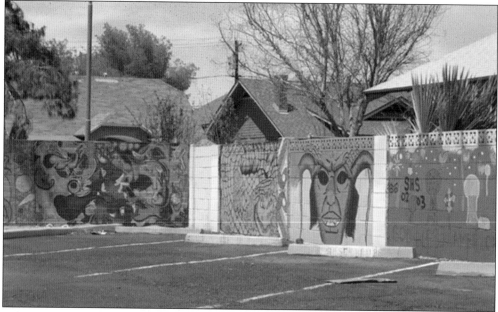

Talented Summit High School students painted their parking lot wall, inside and out, at 719 East Coronado in 2001–2002. In 2007, the school started to refresh the murals and created a "Senior Wall" which gives a sense of continual change for this local art piece. (Photograph by Maureen Rooney.)

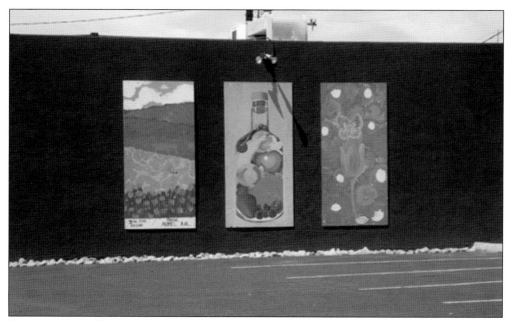

The south wall of 2009 North Seventh Street is home to work done by young artists. These three particular works were done in 2005 and originally hung on the chain-link fence surrounding Phoenix Symphony Hall during its renovation. Young Arts, Inc., which resides in this building, periodically changes the art displayed outside. (Photograph by Maureen Rooney.)

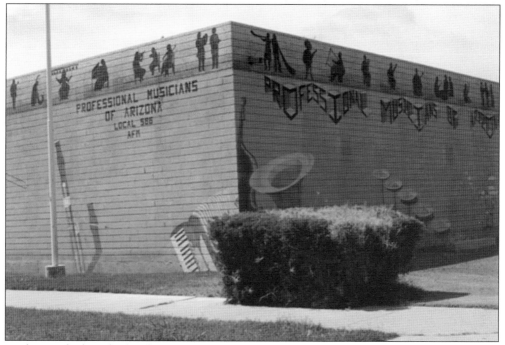

Linda Mundwiler, who lived in Coronado neighborhood at the time, painted this mural at 1202 East Oak Street in the summer of 1998 as part of the CCP. The musical theme was appropriate for this building since it is home to the local musicians union. During a recent face-lift of the building, the mural was painted over. (Photograph by Maureen Rooney.)

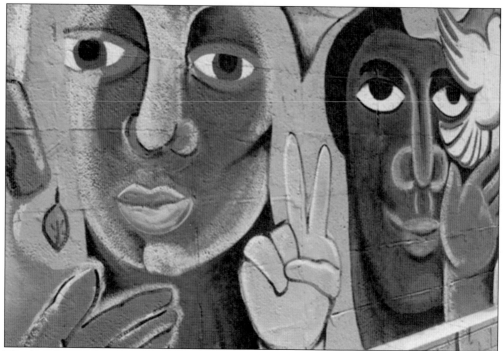

The late Rose Johnson designed the mural on the building of the Mercer Mortuary on the southwest corner of Sixteenth Street and Thomas Road as part of the 1998 CCP. Volunteers and students from the neighborhood assisted with the six-panel project that shows the evolution of Coronado neighborhood through time, including good and not-so-good happenings. The mural encompasses three walls of the building. (Photograph by Maureen Rooney.)

Located on the east wall of what used to be Just Blazed, 1740 East McDowell Road, viewers might think that this bold piece was graffiti. The owner of the business had two of his California artist-friends produce this work in 2007. The bold colors and technique definitely catch the eye of those driving by. Just Blazed (now located on Camelback Road) caters to aerosol artists. (Photograph by Maureen Rooney.)

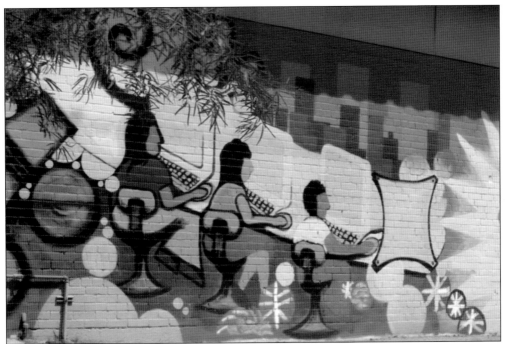

Located on the Fourteenth Street side of old Fire Station No. 5 at 1401 East Thomas Road, this wall originally had a mural painted in 1998 by Angela Cazel-Jahn as part of the CCP grant. This particular mural, painted by Pablo Luna in 2007, replaced the previous mural. The mural content reflects the activities and concerns for family as espoused by Mothers Against Gangs, an organization that formerly resided in this the building. (Photograph by Maureen Rooney.)

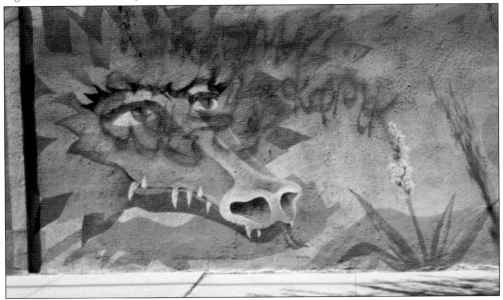

Angela Cazel-Jahn designed this CCP grant-sponsored mural during the summer of 1998. The neighborhood guardian dragon can be found at 2502 North Tenth Street on the block wall facing Sheridan Street. The painting was a collaborative effort between the artist and members of the neighborhood. (Photograph by Maureen Rooney.)

The building at 1202 East Oak Street has been the home of a number of commercial businesses since its construction in the late 1950s. This is the only intersection in the interior of the neighborhood that has commercial structures at all four corners. And each commercial venture is quite different from the other. In the early 1970s, the Professional Musicians of Arizona, established in 1912, purchased the building. As an example of an active creative space in the neighborhood, it offers recital, performance, and meeting space for members of the musicians' union and the benefit of music instructors, students, and other performers. (Photograph by Linda Laird, courtesy of Arizona State Historic Preservation Office.)

The Arizona Showmen's Association was founded in December 1945 as a nonprofit for members of Arizona's carnival and entertainment community. William "Cannon Ball" Bell, Henry Carlyle, Don Hanna, and Hico Siebrand were the founders. While most of the group's activities were social, the intent of the organization was to provide burial funds for indigent workers in the carnival industry. Gatherings, meetings, and high-stakes poker games were the norm for this colorful group. This undated photograph shows the very basic building on the southeast corner of Twelfth and Oak Streets. Today, the building is home to the Tuck Shop, one of the neighborhood's boutique restaurants. (Courtesy of the Arizona Showmen's Association.)

Artists abound in the neighborhood. Architects, welders, painters, photographers, and many more live and work in quiet spaces often unnoticed from the street. One example is Circle 6 Studios (above), which is tucked away behind a small bungalow on East Virginia Avenue. The studio has been quietly making art glass for 15 years and glassblowing for 6. The lot, much larger than most in the neighborhood, was ideal to accommodate the studio and the large ovens where glassblowing is now the appealing forte. A collaboration of artists' work is on display in this studio, which is open during First Friday art events. The piece below is representative of some of the work done in the studio. (Both, courtesy of Circle 6 Studios.)

Five

THE INFRASTRUCTURE OF CORONADO

Built primarily before the turn of the century, the extensive network of agricultural canals and lateral ditches that once supplied irrigation to the valley's extensive farmland were in need of repair and rehabilitation by 1950. In addition to inefficiency due to seepage, the burgeoning urban population required copious amounts of water. As farming gave way to residential development, the Salt River Project's (SRP) agricultural irrigation infrastructure supplied the brick bungalows and petite Tudors with their suburban character. Lush lawns and large ash trees enabled life to be lived out-of-doors with tree-shaded days and nights spent asleep in the backyard. From canal recreation to wet towels draped over windows, the palpable presence of water shaped residential practice.

Beginning in 1950, SRP began lining and piping many laterals to increase efficiency, aesthetic appearance, and reduce growing safety concerns in residential areas. In the early 1970s, the south branch of the Maricopa Canal, what is now Oak Street, was piped underground as part of SRP's efforts to cope with the valley's rapid rural-to-urban transition. As the lateral ditches disappeared from sight, perceptions and uses of water were altered. As urbanization and changing infrastructure—more houses, more people—necessitated changes in water delivery, air conditioning brought desert dwellers inside.

The 1970s and 1980s became an era defined by infrastructure change in Coronado, with subsequent changes in physical form, visual character, social practices, and organization. The expansion of arterial roads and freeway construction encroached on the residential character of the Coronado neighborhood from all sides. As livable "old" houses and commercial buildings were leveled, Neighborhood Housing Services helped Coronado neighbors organize to halt development through the use of conservation and historic zoning. The greater Coronado neighborhood's community organization and physical boundaries were literally born from these infrastructure changes. After several decades of determined efforts to defend the neighborhood from unwanted development, Coronado has spent the last decade defining the kind of community it wants to be. By supporting desired local businesses (restaurants, art studios, and so on) and implementing speed calming strategies, the commercial corridors and varied transportation options have become some of the neighborhood's greatest assets.

This 1924 map of Phoenix shows several of the major canals that bring water to the city. The Grand Canal and the Maricopa are in the upper right. The south branch of the Maricopa, or the little Maricopa, ran due west to Central Avenue. It was this branch that ran through the neighborhood along Oak Street, then known as Canal Street. The branch now runs through a buried pipe. (Courtesy of Arizona State University, Noble Science Library.)

Water was once more visible in everyday life. Irrigation water comes every two weeks during the summer months, making some residential homes and some parks appear flooded. Certainly, it is tempting to play in the cool water. Note the berms in this photograph, which prevent the water from actually entering the house. Coronado and Country Club Park are flood irrigated. (Courtesy of Salt River Project Research Archives.)

100

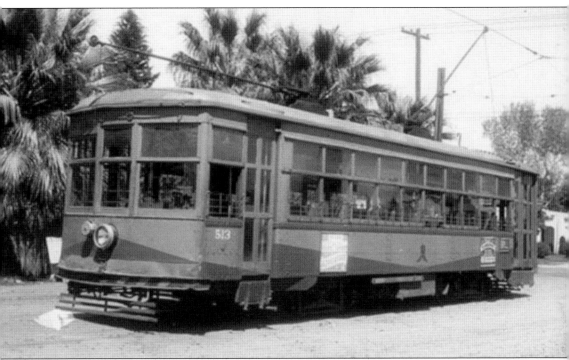

This photograph of No. 513 (originally No. 126) is a car that at one time ran on the Brill Line. The Brill Line (streetcar) came through the Coronado neighborhood, terminating at Tenth and Sheridan Streets. The bright yellow trolley cars ran daily until 1948, when city buses replaced them. Shortly after the buses totally replaced the trolleys, riders often had to be reminded to wait on the curb rather than stand in the middle of the street. The streetcar route encouraged the growth of small businesses particularly at major intersections. A number of these buildings in the neighborhood still exist; some as artists' studios, and others have been converted into homes. Today, city bus routes serve all three historic neighborhoods. (Courtesy of the Phoenix Trolley Museum.)

By 1922, about 42 miles of Phoenix streets were paved. Many homeowners resisted having their neighborhood streets paved to avoid increased taxes. Gradually, they realized that paved streets were easier to maintain and resulted in less dust inside of their homes. Paving projects slowed during the Depression; although, much of the work was done by the Public Works Administration and Works Progress Administration. Oddly enough, a few of the streets within the neighborhood are concrete rather than asphalt. As these concrete streets are part of the historic infrastructure of the neighborhood, they must be retained. (Photograph by Donna Reiner.)

Concrete sidewalks are part of the Coronado and Brentwood neighborhoods' historic fabric. These stamps, located in the sidewalks and curbs, identify a concrete mason, union, or company. Walkers will find 1936 to 1942 WPA markings, especially on block corners. One company worked hard in 1937 (above). Daley Corporation, founded by George Daley, poured sidewalks, driveways, curbs, and gutters in the Coronado neighborhood that year starting from Eighth Street and working east. Careful searching will reveal some sections labeled Daley-Tulloch Company (1946) after the company expanded. V.F. Rodriquez's imprint was rather creative in this spot (below). (Both photographs by Donna Reiner.)

In February 1935, the City of Phoenix purchased a parcel from James Realty for $12,050. In the following year, $50,000 from the municipal fund plus some Public Works Administration monies spurred the construction of the swimming pool, athletic fields, and a lighted ballpark (above). As a result, Coronado Park was one of the first Phoenix parks funded with New Deal monies. Prior to this time of federal funding, the city of Phoenix had relied on private donations of parcels to be used for public parks. When the Womack subdivision (between Thirteenth and Fourteenth Streets from Monte Vista to Palm Lane) was started in 1939, the Coronado Park was touted as one of the neighborhood amenities. This large neighborhood park will undergo renovations in 2013 while still retaining its historic elements, such as the lights and the pool house (below). (Both photographs by Donna Reiner.)

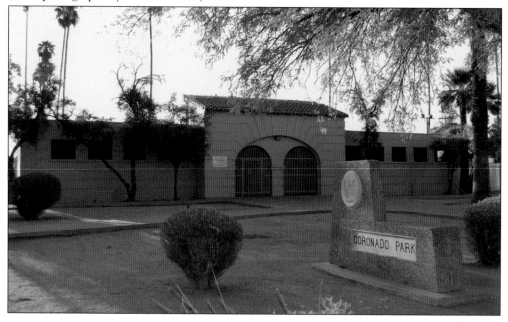

Located at Virginia Avenue and Fifteenth Street, this "pocket park" is the smallest and "newest" (1943) park in the neighborhood. The park had become a safety hazard, so a number of concerned neighbors worked with the Phoenix Parks and Recreation Department on a renovation. Sales tax and bond monies, plus $1,000 raised from the 2010 home tour, primarily funded the project. Completed in 2011, the park makes up for its small size with a stellar playground. (Photograph by David Cook.)

Designed as part of the original Country Club Park subdivision, the 2.5-acre oval park has become a resource for the neighborhood. During the day, it is the neighborhood's de facto dog park. Even without fencing, the park remains safe for canines thanks to the slow traffic hazard resulting from adjacent curvilinear streets. At night, the Coronado Neighborhood Association has hosted family friendly "Movies in the Park" during the cooler months. (Photograph by David Cook.)

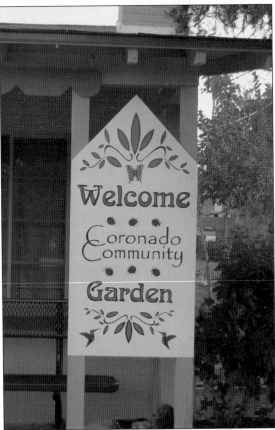

Under the auspices of then neighborhood association president Cletus Montoya, a group of individuals got together to start a community garden in the yard adjacent to the association's office on East Virginia Avenue. Many had gardens of their own, but this was a means to share their knowledge with the larger community through seed exchanges and "how to" classes on topics such as irrigation installation and desert vegetable gardening. Part of their neighborhood pride effort even included constructing a wooden replica of the McDowell Road arch (above). The neighborhood newsletter has, and continues to, highlight the goings-on of the community garden. This garden sign is clearly visible from Virginia Avenue (left). (Both photographs by Donna Reiner.)

The greater Coronado neighborhood has a number of major intersections on all four sides. Above is the intersection of Sixteenth Street and Thomas Road. A mile south of Thomas Road is the intersection of Sixteenth Street and McDowell Road (below). Both of these photographs were taken in 1986, and 25 years later, these intersections still look quite similar with only the names of the businesses having changed. Heralded now as "Calle 16," this arterial street has become a corridor of Latino urbanism, boasting mural tours and some of the best Mexican food in town. (Both, courtesy of Arizona Historical Foundation, Allan Dutton Collection.)

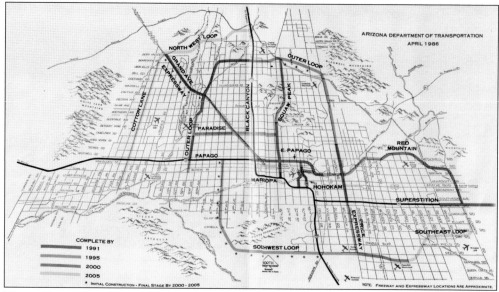

This 1986 map produced by the Arizona Department of Transportation shows the approximate locations of the freeways and expressways that were planned at the time. The greater Coronado neighborhood lies west of the Squaw Peak Parkway and two miles south of the Paradise Parkway. The former is now called Piestewa; the latter was never built. (Courtesy of the Phoenix Public Library, Arizona Room.)

With the construction of the Squaw Peak Parkway, now Piestewa Parkway or State Route 51, the eastern boundary of the greater Coronado neighborhood was established. This early 1988 photograph looking east shows the bridge being built over McDowell Road. (Courtesy of Arizona Historical Foundation, Allan Dutton Collection.)

Taken in December 1984, this picture shows McDowell Road from Seventeenth Street looking west. By 1989, the City of Phoenix had begun a major effort to improve traffic flow by widening this street to six lanes and removing on-street parking. This "improvement" may have also sped up the decline of the commercial area, as fewer people were interested in coming to a place where parking was difficult. (Courtesy of Arizona Historical Foundation, Allan Dutton Collection.)

In an attempt to beautify a nearly two-mile section of McDowell Road and restore it to its earlier splendor when it was known as Miracle Mile and Governor Row, the East McDowell Road Civic Association worked with the Phoenix Arts Commission to erect this arch between Sixteenth and Seventeenth Streets to mark the entry to the downtown area. The McDowell Gateway Arch, designed by Scottsdale sculptor Michelle Stuhl, was erected in 1991. (Photograph by Donna Reiner.)

This street divider on Virginia Avenue between Dayton and Twelfth Streets on the south side of North Phoenix High School was one of the accomplishments resulting from a 2004 Fight Back West grant awarded to Coronado to mitigate traffic. The artist, Joan Waters, incorporated the bungalow design into the piece as a reflection of the types of homes constructed in the neighborhood and also as a reminder of the neighborhood's logo. Completed in February 2008, the Virginia Avenue project also included the construction of the bulb-outs lining Virginia Avenue whose drought-tolerant landscaping is maintained by neighbors. (Photograph by Donna Reiner.)

Six

SENSE OF PLACE
AND PRESERVATION

The 1966 National Historic Preservation Act, which ushered in the legal toolkit needed to preserve historic structures, places, and neighborhoods, originated as a direct response to the pervasive demolition of historic sites commonly initiated by federal urban renewal programs. At the local level, especially during the decades following the Preservation Act, the impetus behind residential historic districts is largely understood to be less about the preservation of history and more about halting change in the built environment.

Like many newer cities in the United States, the construction of freeways that border and slice the central city was the primary inspiration behind historic preservation in Phoenix. Construction of the Interstate 10 Freeway resulted in the destruction of 600 older homes between 1974 and 1975; by 1985, the first Historic Preservation Ordinance was adopted by the city. Unlike many eastern and southern cities with a legacy of residential historic preservation originating in the first half of the 20th century, preservation in Phoenix reflects contemporary development pressures and quality-of-life interests, rather than the inheritance of preservation strategies. With the creation of 35 historic districts since 1986, Phoenix has embraced residential historic preservation as a central strategy of urban redevelopment and community identity.

In Coronado, the movement toward historic designation began with the neighborhood revitalization efforts of Neighborhood Housing Services (NHS) of Phoenix in 1975. Coronado was chosen as the first NHS target community in Phoenix to benefit from the unique partnership NHS created between community residents, local government, and the private sector. In 1985, Coronado's Special Conservation District was completed. Formally designated in 1986, Coronado is one of the largest and oldest historic districts in central Phoenix. The community improvement efforts in the Greater Coronado have not ceased with historic designation; street cleanups, home tours, listservs, and numerous grant-writing efforts keep residents engaged in making an active, inspired neighborhood.

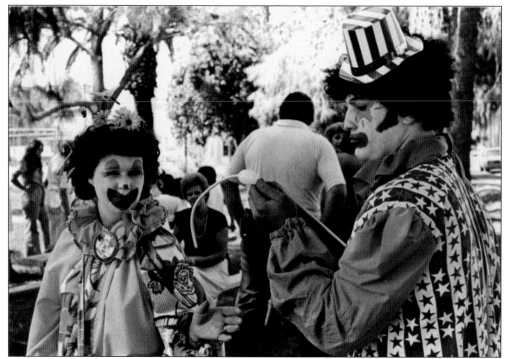

Even before designation of any of the historic districts in the greater Coronado neighborhood, there was a sense of community. Neighborhood Housing Services hosted various festivals in the park. This one took place in the fall of 1977. What would an event in a park be without clowns making balloon animals (above)? Below is a demonstration of Tinikling, the national dance of the Philippines. This intricate dance requires one set of performers to rhythmically open and close the bamboo poles while the dancers step between and outside them. (Above, photograph by John Booth; below, photograph by Liz Maldonado.)

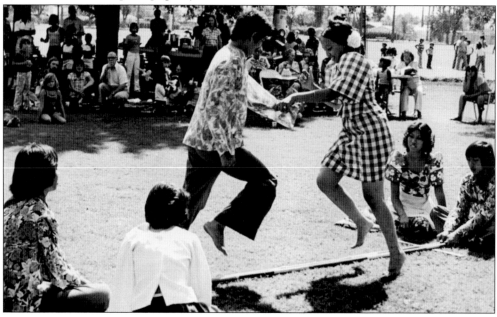

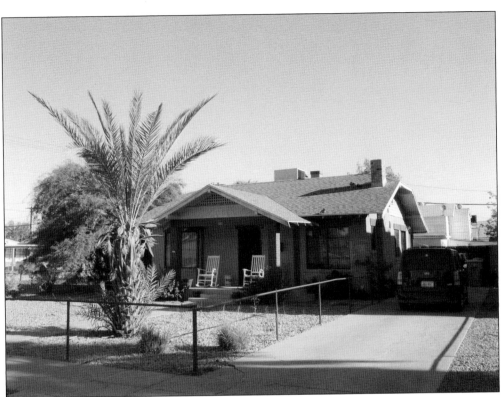

The nonprofit organization Neighborhood Housing Services (NHS) chose Coronado as the first community in Phoenix to benefit from its urban revitalization services. The organization's first office was located at 1002 East Palm Lane (above). After moving to 1546 East Willetta Street in the Brentwood area, the Palm Lane property was reconverted to a residence and sold. NHS provided home improvement assistance, encouraged neighborhood communication and involvement, spearheaded the original gathering of information on Coronado homes before the neighborhood was ever listed on the city or national historic registers, and started what has been a very successful Coronado neighborhood home tour. The first home tour in 1982 was advertised as "NHS's gift to Phoenix" (right). (Both, courtesy of the Coronado Neighborhood Association.)

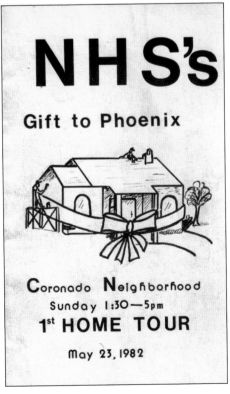

113

ARCHITECTURAL STYLES

BUNGALOW (1905-1930)
This is an import from California and features low pitched gable roofs, a wide gabled porch/portico, and exposed rafter ends.

SPANISH COLONIAL REVIVAL (1905-1925)
This style is typified by white stucco walls, red tile roofs, elaborate ornamentation, arches, and often iron window grilles.

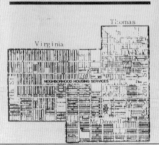

CRAFTSMAN BUNGALOW

HISTORIC SURVEY OF THE CORONADO NEIGHBORHOOD

Neighborhood

To be listed in the National Register of Historic Places and the Phoenix Historic Register is a rather long and involved process. It was Neighborhood Housing Services of Phoenix that spearheaded the process for Coronado in the early 1980s. Using this brochure (above and below) to inform the residents about how they could help, NHS moved forward. Coronado Neighborhood Association files contain notes from oral interviews and some of the literature research. But some items related to the neighborhood's history have been lost or misplaced over the years. This is understandable when considering much of the material work was donated to the all-volunteer group. (Both, courtesy of Nona DiDomenico.)

NHS
Neighbors Improving Neighborhoods.

HISTORIC SURVEY UNDERWAY

NHS has recently been informed that its proposal to the State Historic Preservation Office has been approved. Now the next step needed to preserve the Coronado Neighborhood as an intergral part of Phoenix's past, is to conduct an in-depth survey of its historical resources. But we cannot accomplish this alone. We need volunteers who are interested in this neighborhood's past and are willing to contribute their time to tracing its history.

VOLUNTEERS NEEDED

The function of the volunteer will be to assist the historic survey consultant by performing various types of research. The research will include:

A. Physical Survey; this will include an inventory of the current built resources in the Neighborhood.

B. Literature Research; this will include scanning Phoenix newspapers from approximately 1903 to date for information about the community.

C. Oral Interviews; long time residents of the Neighborhood can provide much needed insight into the beginnings of our area. These residents must be identified and interviewed.

D. Photography; Current photos of the Neighborhood must be taken, as well as the development of a portfolio of old photographs of the area.

Besides the very important benefit of assisting in reserving a spot in history for the Coronado Neighborhood, a volunteer can expect other benefits. For example:

The volunteer recieves free training on the intricacies of performing architectural research.

Under the charitable contributions provisions of the Internal Revenue Code, volunteers may deduct many of the costs accrued through assisting with the survey. Some of the costs may include automobile mileage, bus fare, photocopies, and parking.

The volunteer can count his or her time spent assisting in the survey as a job experience, as if it were a paid position.

114

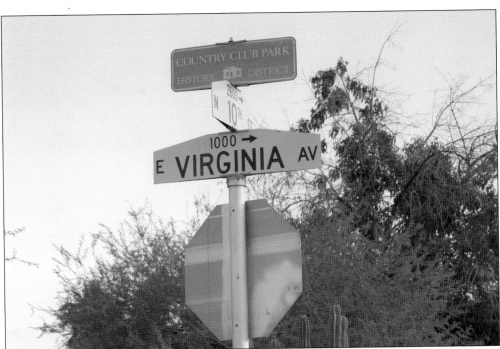

Blue historic neighborhood signs delineate the boundaries of the historic districts as recognized by the City of Phoenix. Newly designated historic neighborhoods look forward to receiving these signs. In fact, there has generally been a ceremonial placement of a sign following designation for promotional purposes with city dignitaries and neighborhood representatives. (Above, photograph by Donna Reiner; right, photograph by Maureen Rooney.)

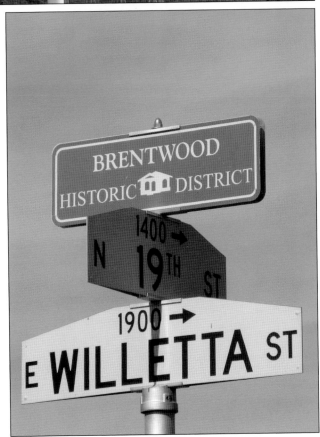

As the neighborhood coalesced, it became important to create visible signs. One of the first tasks was to establish a symbol and logo. This picture (left) shows some of the various suggestions that were then voted upon. Sue Neil, a neighborhood resident, designed drawing No. 5 that was selected to be the logo for the newly formed neighborhood association. Her ability to capture an iconic and enduring quality of Coronado is evidenced by the continued usage of this logo today. Selection of a bungalow as the neighborhood symbol was appropriate as one can find many variations of the Bungalow style within the neighborhood boundaries. At first glance, bungalows may look pretty much the same, but careful examination highlights the differences; rooflines, windows, and gables make for subtle exterior variation. The interior then, as now, reflects the character of the owner. (Left, courtesy of Nona DiDomenico; below, courtesy of the Coronado Neighborhood Association.)

The Comprehensive Community Program management group is standing near Tenth and Sheridan Streets (above) following the completion of another project. Those pictured include city staff, police, the district councilmen at the time, and neighbors. The Van der Veen kids, Josh and Cleo, are seen holding the sign before it was placed in its frame (right). (Above, courtesy of Maureen Rooney; right, courtesy of Coronado Neighborhood Association.)

This metal sign in the shape of a bungalow, one of the most common architectural residential styles in the greater Coronado neighborhood, marks various entrances to the neighborhood. Originally, the signs were designated for only a portion of the greater Coronado neighborhood. But the Phoenix Historic Preservation officer wisely insisted that they be interspersed throughout. City Councilman Michael Nowakowski (District 7), neighbors, and other city employees dedicated the "banners" with a ribbon cutting in 2009. The signage was funded through a Fight Back West grant to the neighborhood. No other historic neighborhood in Phoenix has such a distinctive marker. (Photograph by Maureen Rooney.)

For more than 20 years, the neighborhood association has held an annual home tour as means to share the unique homes, qualities, sense of place, and historic qualities of the neighborhood with the public. This neighborhood newsletter described the homes to be seen on the first tour sponsored by the Coronado Neighborhood Association. The home tour would go on to become the primary fundraiser for the association and an influential community-building activity. (Courtesy of Jerry and Marge Cook.)

The Coronado Neighborhood Association is "organized for the purpose of preserving and improving the life associated with the residential characteristics of the community." To this aim, the association invites new and long-standing residents to showcase their historic homes on the annual home tour. Tour-goers and homeowners alike are inspired by new ways to protect and preserve these homes and surroundings for future generations. (Courtesy of the Coronado Neighborhood Association.)

the·CORONADO·NEIGHBORHOOD·association·
NEWSLETTER

P.O. Box 5215, Phoenix, AZ 85010 January 1989

Letter from the President

Hopefully, we have all survived the CHRISTMAS SEASON and are now beginning a brand new year.

It appears that 1989 will be an exciting year and I look forward to serving you as your President Indeed life is never boring in CORONADO with the forthcoming battle with our CORPORATE NEIGHBOR? ? ? good ole Circle K.

As you are aware the City Council did not approve the "USE PERMIT" for the proposed Circle K store at 16th Street & McDowell. Circle K has filed a lawsuit against the City of Phoenix including each Council Member as well as myself and two members of the Coronado Neighborhood Association.

Well folksregardless of how you feel about the sale of wine and beer at 16th & McDowell, I certainly hope you have strong feelings about the intimidation of residents of a CENTRAL CITY NEIGHBOR-HOOD who have only exercised the right as a citizens . . . I feel this lawsuit is a dangerous precedent and one that everyone of you should RAISE YOUR VOICES loud & clear in protest of such tactics BEING USED BY ANY CORPORATE POWER to stymie neighborhoods from protecting their homes . . . We still have "people power" in this city and I believe it would behoove the commercial sector to listen to us INCLUDING THE BIG UGLY RED CIRCLE . . . PLEASE SUPPORT YOUR CITY COUNCIL NEIGHBORHOOD AND YOURSELVES. . . .

Alyce Manevitz, President

January Meeting

There will be a meeting of the Coronado Neighborhood Association on Thursday, January 5, at 7:30 P.M. at the YWCA, 755 E. Willetta. Featured speaker is Jerry Martinez from the Arizona Public Service who will discuss various ways to lower your APS bill, an interesting topic from which we all could benefit.

If anyone has specific topic they would like to have covered, please contact Arlene Bunten (thru CNA), and we will attempt to arrange for a speaker. Encourage your neighbors to come to the meetings and join the Association. The more support we have, the stronger our group. This is your neighborhood -- be proud of it.

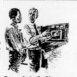

Coronado in the News

The lawsuit, by Circle K against the Phoenix City Council and three CNA members, has generated more coverage by local news media than most of the other activities we do. Radio talk shows, Gazette column, regular news article, etc., all appear to support our view of the world – as opposed to the corporate one.

CLIP & SAVE

City of Phoenix Police Phone Numbers

Special Investigation Bureau.....262-6751
 Vice Drugs

Community Relations...262-7331
 Confrontation Squad
 Gang Squad
 Parks Detail
 Silent Witness
 Crime Prevention Unit
 Block Watch
 School Programs

Squaw Peak Precinct...262-6101
 (North of Oak Street
 -includes Oak)

Sky Harbor Precinct...262-6171
 (South of Oak Street)

9-1-1 Emergencies ONLY
 Crime in progress
 Crime that has already
 occured with suspect
 Situation involving violence

Crime Stop......262-6151
 All other requests for
 Police Service

CLIP & SAVE

Long before easy access to computers and software programs, this two-sided photocopied newsletter was sent to the members of the neighborhood (left). Computers, great cameras, and the desire to improve the look of the association's primary form of communication led to the development of a slick magazine format. Today, the *Dispatch* (below) provides information to residents and others who are interested in the area. Articles range from neighborhood historical facts, upcoming events, gardening tips, safety information, and association business. The new professional magazine format inspired at least one other Phoenix historic district to follow suit. (Both, courtesy of the Coronado Neighborhood Association.)

the CORONADO
DISPATCH
MAY /JUNE 2011

An
AMAZING
Tour

COUNTRY CLUB PARK HISTORICAL PROFILE

Friendly neighborhood living in the ♥ *of Phoenix since 1939*

"The World War II Homes of Phoenix"

This book was collaboratively produced by the Country Club Park neighborhood in the early 1990s. The intent was to show some of the changes in the area but also to promote the strong community feeling the residents have for their particular district. A document such as this helps in the preservation of the neighborhood as it strengthens pride in the residents' homes and history. (Courtesy of Donna Reiner.)

In 1998, the Greater Coronado Neighborhood Association received a grant from the Arizona State Parks Board Heritage Fund to produce this booklet. Thirteen homeowners graciously allowed the team to photograph and document interior details, such as fireplaces, built-ins, doors and door hardware, arches, walls, and ceilings. The booklet shares the value of historic preservation and celebrates the craftsmanship found in Coronado. (Courtesy of Donna Reiner.)

Historic Interiors
of the Greater Coronado Neighborhood

Just prior to the 2011 home tour, the northwest corner of Twelfth and Oak Streets gained a new landmark. Salem Elia, owner of Sunshine Market and a longtime supporter of the Coronado home tour, erected the ornamental wall sign as a symbol of his pride in the "hood." (Photograph by Donna Reiner.)

The Twelfth Street and Oak Street roundabout (Oak Street circle) was constructed as part of a hugely influential Fight Back West grant awarded to Coronado in 2004. The traffic circle has become a point of pride and centrality in the neighborhood thanks to loyal residents who maintain the beautiful landscaping and post banners announcing the home tour in the spring and American flags on Veterans Day. (Photograph by Wayne Murray.)

This driving tour map shows the 35 residential historic districts within the Phoenix city limits. A grassroots project sponsored by the Phoenix Historic Neighborhood Coalition, the map won an Arizona Heritage Preservation Honor Award. Four editions and over 75,000 copies later, the map continues to be a popular item. A similar group in Tucson, Arizona, followed suit by creating a Tucson driving map in 2011. (Courtesy of Donna Reiner.)

Historic Neighborhoods of Phoenix

Self-Guided Driving Tour

A Publication of the
Phoenix Historic Neighborhoods Coalition

FOURTH EDITION 2006 Printing courtesy of **SRP**

Coronado

HISTORIC DISTRICT

1907-35

The City of Phoenix Historic Preservation Office received a grant from the Department of the Interior, National Park Service in the 1990s. With those funds, the office produced a booklet for all the historic districts that existed at the time. The content summarized the history of the neighborhood and its significance in Phoenix's history. No longer published, it was a nice gift to new residents while the supplies lasted. (Courtesy of the Coronado Neighborhood Association.)

Strange as it may seem, these beautiful creatures (above and left) freely roamed a small section of Coronado, becoming a unique part of the neighborhood's recent history. No one admits to where the peacocks came from, but they have been Coronado residents for over 30 years. Recently, a schism arose between those who loved them (those who fed them) and those who did not (those whose cars were scratched). Protestations regarding their screeching, scratching of cars, and indiscriminate pooping finally forced their removal to a new home. Keep an eye out for escapees that are rumored to have been spotted. (Both photographs by Kim Blake.)

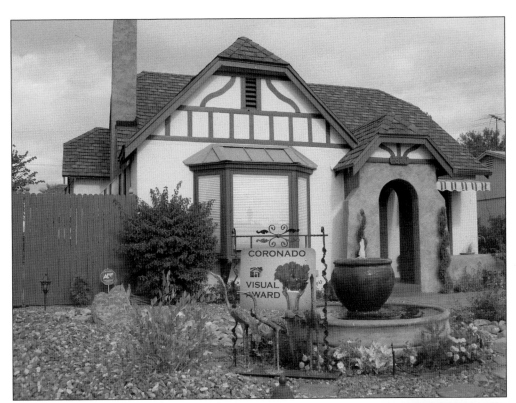

The Coronado Visual Award originated in 2007 as a way for residents to publicly acknowledge the neighborhood beautification efforts of local residents and businesses. Thomas Blee-Carlyle and Aaron Carter were the first recipients of the Visual Award (May 2007) for their restoration efforts at 1800 East Monte Vista, a 1925 Tudor Bungalow that was also featured in the 2006 Coronado home tour (above). Robert Canady was the recipient of the February 2008 Visual Award for his outstanding native wildflower display at 2207 North Twelfth Street (right). Nominations for this visual award continue and are accepted at any time. (Both photographs by Wayne Murray.)

Getting Arizona Involved in Neighborhoods (GAIN) originated with the National Night Out programs, which focused on crime prevention (above). Coronado's GAIN event has grown to include other entities that make up the neighborhood's infrastructure plus adjoining neighborhoods. Representatives from the city police and fire departments, social services, churches, and educational organizations all come together one afternoon in October to help residents celebrate the neighborhood community (below). (Both, courtesy of the Coronado Neighborhood Association.)

For several years, the Coronado Neighborhood Association, in conjunction with the Seventh Street businesses that border the neighborhood, sponsored a monthly social event named "Seventh on Seventh." This monthly gathering held on the seventh day of the month was an opportunity for neighbors and friends to socialize at one of the businesses and highlight the neighborhood's offerings to downtown residents. Often, the evenings had a specific theme. "Sunday on Seventh" was an offshoot organized in conjunction with one of the home tours (above and right). In an effort to expand the destination to businesses located on other streets, the event is now called "Coronado Night Out." (Both, courtesy of the Coronado Neighborhood Association.)

Schedule of Events

Spend Your
Sunday On
7th
Street

Chalk art ready to be viewed all day
Piccolo Cucina, Mac Alpines,
Sheridan Square, Café La Bella/Virginia Market,

Breakfast – Starting at 7:30 am
Drip Coffee Lounge serving breakfast and coffee

Breakfast – Starting at 9am
Virginia Market complimentary coffee and doughnuts

Lunch/Dinner– Starting at 11am
Lisa G's, Mac Alpines, Virginia Market, Drip Coffee Lounge

Wine specials – Starting at 11am
Lisa G's Wine Bar

Shopping – Starting at 11am
Mac Alpines Restaurant and Soda Fountain

Artists – Starting at 11 am
Drip Coffee Lounge, Mac Alpines,
Piccolo Cucina, Café La Bella/Virginia Market

Wine Tasting – Starting at 4pm
Café La Bella/Virginia Market

Dinner and Drinks Starting at 4pm
Trente Cinq 35, Café La Bella

Chair Massage by Michelle Clancy 4 to 7pm
Drip Coffee Lounge

Entertainment – Starting at 4pm
Piccolo Cucina – choir
Mac Alpines – family movie
Sheridan Square – music
Café La Bella/Virginia Market – music

Main Stage – Starting at 5:30pm, Camelback Contractors
Fashion Show by Lola Lola and Arte Puro – hair by Salon 7.
Local bands, Loveblisters, Sleepwalk, A Robot